Creating Celtic Animal Designs

A Fresh Approach to Traditional Design

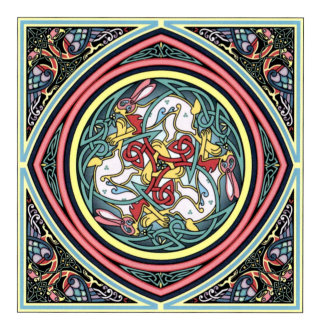

CARI BUZIAK

Dover Publications, Inc.
Mineola, New York

Copyright

Copyright © 2020 by Cari Buziak
All rights reserved.

Bibliographical Note

Creating Celtic Animal Designs is a new work, first published by Dover Publications, Inc., in 2020.

Library of Congress Cataloging-in-Publication Data

Names: Buziak, Cari, author.
Title: Creating Celtic animal designs : a fresh approach to traditional design / Cari Buziak.
Description: Mineola, New York : Dover Publications, Inc., 2020. | "*Creating Celtic Animal Designs* is a new work, first published by Dover Publications, Inc., in 2020." | Summary: "Many instruction books focus on how to duplicate a given set of designs, but this unique work shows how to create your own. Cari Buziak presents simple, step-by-step directions for incorporating animal forms into Celtic designs"—Provided by publisher.
Identifiers: LCCN 2019028501 | ISBN 9780486837314 (trade paperback)
Subjects: LCSH: Decoration and ornament, Celtic. | Decoration and ornament—Animal forms. | Drawing—Technique.
Classification: LCC NK1264 .B887 2020 | DDC 745.09364/0166—dc23
LC record available at https://lccn.loc.gov/2019028501

Manufactured in the United States by LSC Communications
83731901
www.doverpublications.com

2 4 6 8 10 9 7 5 3 1
2019

Dedicated to Liberty. With all my love.

Photo Credits

All photos are from Getty Images.

PAGE	DESCRIPTION	CREDIT
14	Peacock	LordRunar
14	Eagle	Cecile Gambin
14	Egret	Jonathan Carter
17	Hawk	AttilaBarsan
18	Bird Foot	Dan Badiu
34, 36, 39	Hound	Ashva
50	Lion	DVrcan
53	Lion Head	Anagramm
62, 67	Hare	Byrdyak
74	Horse	Julesru
86	Snake	Jamie Hall
94	Salmon	Willard
102	Fox	GlobalP
110, 111	Boar	anankkml

Contents

How to Use This Book 1

Freehand Knotwork 3

Birds 13

Hounds 33

Lions 49

Hares 61

Horses 73

Snakes 85

Fish 93

Foxes 101

Boars 109

Techniques & Materials 117

Biography 122

Creating Celtic Animal Designs
How to Use This Book

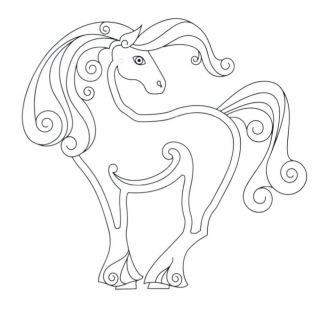

Celtic animals have decorated many beautiful stone, metal, and embroidery creations and are featured in the old illustrated manuscripts. This book provides the tools to create traditional animals like hounds, lions, snakes, and birds as well as less common animals.

The first chapter teaches the basics of Celtic knotwork interlace—freehand style! I used a grid method in my previous book *Creating Celtic Knotwork Designs*, but this freehand method is more useful for creating animals.

The early chapters cover drawing animals step-by-step in great detail. In subsequent chapters, the instructions speed up and build on information covered in previous chapters. After learning the basics, it's easy to create variations of these animals and animals that have never been drawn in a Celtic style. Mix and match elements, adding manes, tails, toes, and inner details to give the animals personalities and unique looks.

Each chapter begins with a single version of the animal that presents its characteristic elements. There are complex designs with more than one animal plus guidance on how to combine them in the most interesting ways and develop them into more complicated patterns. No special drawing skills are necessary. With a willingness to experiment and a bit of practice, you'll be making Celtic animal designs in no time.

FREEHAND KNOTWORK

FREEHAND KNOTWORK

❧ Freehand Knotwork

Celtic animals have one thing in common—they're all tangled up. Elongated ears, tongues, tails, and body parts act like accessories and can be woven like Celtic knots, as can the bodies themselves. Dogs might be intertwined with birds or lions, making a complex panel of knotwork and animals that are all woven together.

Let's look at the basics of Celtic knots and how to draw some simple, interlacing knot designs. These can be used to embellish the animals.

Freehand knotting is a bunch of looping lines that first overlay each other and then weave together. Any squiggle of lines can be made into a freehand knot by following two simple rules:

Rule #1: Only two lines can cross over each other at any given point or "intersection."
Rule #2: Enough room must be left at each intersection so that the line can be woven later.

Incorrect	**Correct**

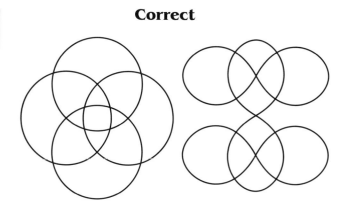

In the left example, all the lines cross each other in the center, which breaks Rule #1. In the second example above, the lines cross together too closely, which breaks Rule #2.

In the corrected versions above, the circles and figure eights are spaced out so that no line passes too closely to another and only two lines cross in any given place.

Creating Celtic Animal Designs

❧ Freehand Example 1

To weave a knot, expand each line into a ribbon or strip that can be woven. The easiest way to do this is by drawing the guidelines of the design lightly in pencil. Using the first line as a guide, add another set of lines to either side of it, as shown in red.

Offset the original line by a little or a lot. The distance determines how wide the final knotwork strands are. It doesn't matter how wide they are, but don't forget Rule #1 or Rule #2. If the lines are cramped in an area because there isn't enough room, redraw that part so it's spaced out a bit more.

After doubling up all the lines, you'll be able to see how the knot will look. If working on scrap paper, leave your original light pencil marks. If working on final good paper, erase them.

FREEHAND KNOTWORK

Freehand Example 1...

Here's the design with the initial light pencil lines erased.

The next stage is to weave the design. Pick any intersection of two lines, and erase it so that one line appears to go "over" or "under" another. Continue along that strand and the rest of the strands until they're all woven.

Pick an intersection randomly and erase it so that one strand appears to go over the other, as shown in red in the upper left intersection.

Creating Celtic Animal Designs

Freehand Example 1...

Follow that uppermost strand or ring. Because that first intersection was an "over," the next should be an "under." Then the next is an "over," followed by an "under" again. Continue switching between "over" and "under" until the end. The top ring is now completely woven.

The rest of the rings are woven in the same manner. For the ring on the middle right, the top intersection was completed along with the top ring. This is a good place to start. If that intersection was an "over," then the next intersection is an "under," and so on around the ring.

FREEHAND KNOTWORK

Freehand Example 1...

Finishing each ring completes parts of other rings, which is very handy! In this example, when the bottom ring is finished, so is the entire knot design.

ଐFreehand Example 2

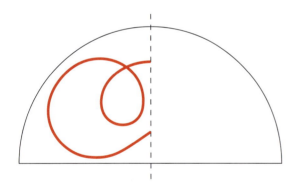

Begin with a semicircle divided in half. Draw a knotwork strand that makes a loop near the center middle area, as shown in red.

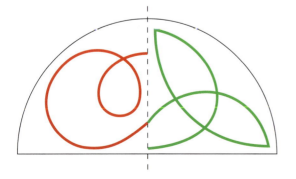

Continue the strand into the right-hand segment, as shown in green.

Creating Celtic Animal Designs

Freehand Example 2...

Double-check that there's enough space between all the lines and intersections by flipping or mirroring the pattern horizontally. If anything is too close, make adjustments. Leave a nice gap around every intersection so that there's enough room to expand the lines.

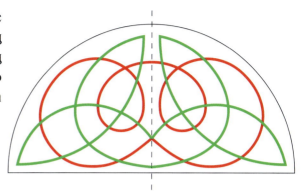

After expanding the guideline with a red line along the outside and a green line along the inside, verify that there's enough room to complete the weaving.

The design could be woven as it is currently, or it can be developed into a larger design that would fill a circle. To do this, "break" or "snap" the knot lines that come near the center line.

FREEHAND KNOTWORK

Freehand Example 2...

Those lines are then rejoined across the center line, as shown in red, so the two halves are connected and continuous.

Whether making a semicircular design or a full circle, the weaving is done the same as before. Double up the lines on either side of the original line, and then weave using the "over" and "under" technique.

Creating Celtic Animal Designs

Durrow's Cross © 2008

BIRDS

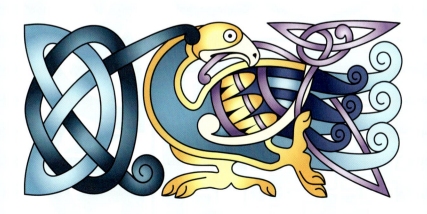

BIRDS

❧ The Basic Bird

Eagles and peacocks are the birds most frequently seen in *The Book of Kells* and *The Lindisfarne Gospels*, two canonical Celtic books from circa the eighth century CE. The eagle is a symbol for the evangelist St. John, and the peacock symbolizes the purity of Christ, because in ancient times people thought that the flesh of a peacock was so pure that it would never rot. There's no reason to limit modern Celtic art to just two kinds of birds. Birds provide plenty of opportunity for color and detail after adding their wings and tail feathers, and there's a wide variety of birds that can serve as inspiration.

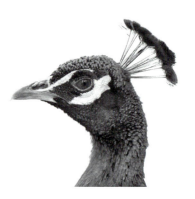
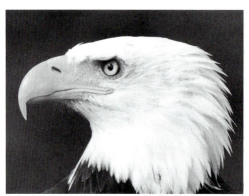
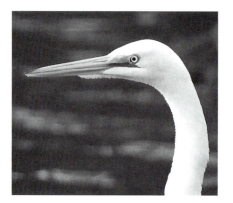

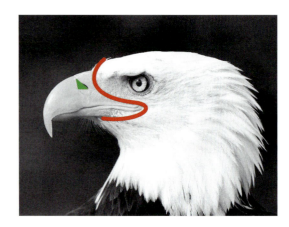

Three types of birds are shown above. Even though they're very different, there are some common elements.

There is a dividing line, shown in red, between the feathers on the face and the hard beak, which is shaped like a curve. This dividing line is simplified and smoothed out when drawing Celtic birds, but it is essentially the same. The nostril, shown in green, can appear near the beak tip or close to the face.

The beak is drawn as in real life, but it varies depending on the type of bird. The beak could end with two tips tight and close together, like a peacock's beak, or with a sharp hook, like an eagle's.

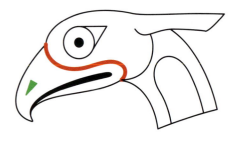

Creating Celtic Animal Designs

The Basic Bird...

Drawing a basic bird's head shows how to bring the elements discussed on the previous page into play.

The first stage is making the head. Draw a shape that looks like a speech bubble in a comic book. It's round or oblong, with a tapered little point on the bottom.

The beak begins from a point high on the upper rounded portion, where the forehead would be. The beak can be long or short, with a big or small tip. The shape gives the bird a different character or emotion—regal, fierce, friendly, or comical.

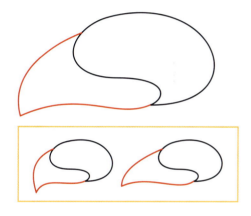

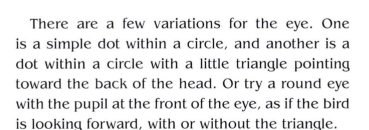

The mouth extends from the tip of the beak to the round hollow near the cheek. The nostril can be a little teardrop or a triangle.

There are a few variations for the eye. One is a simple dot within a circle, and another is a dot within a circle with a little triangle pointing toward the back of the head. Or try a round eye with the pupil at the front of the eye, as if the bird is looking forward, with or without the triangle.

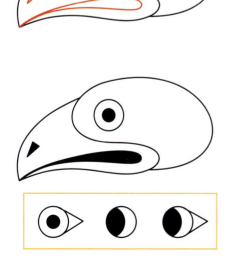

BIRDS

The Basic Bird...

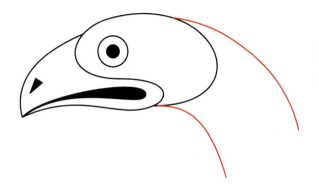

The bird's neck extends from the back of the top of the head and under the throat, where the beak joins the head—the point of the speech bubble.

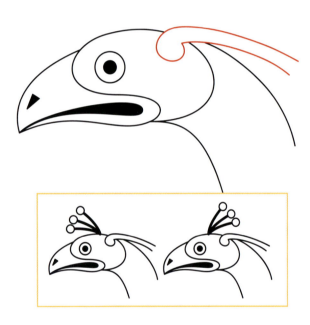

From the top of the back of the head, add a little nub with a long tail. This crest is usually lengthened and woven up as a freehand knot around the bird. Try different crests as well—or mix and match!

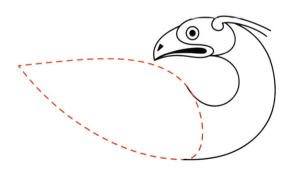

The bird can face forward or backward over his body. To make the body, add a large teardrop shape to the neck. Celtic bird necks are typically longer than a real bird's would be, so don't be afraid to make it long and then add the teardrop.

Creating Celtic Animal Designs

The Basic Bird...

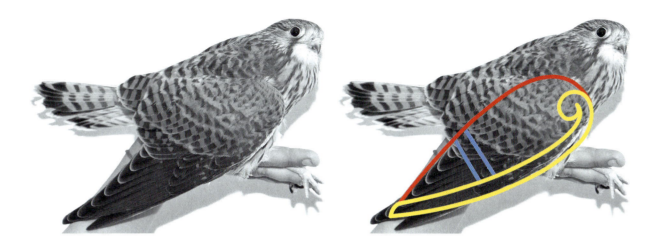

The pose of the bird in the photo depicts how a wing is shaped like a teardrop, as shown in red and yellow. For a Celtic bird, the wing connects to the shoulder with a long curled shape, which is the bottom of the teardrop, as shown in yellow. A Celtic bird usually has the wing folded tight against the body, so all that's visible is the wing—and nothing from its back or body. This makes it easier to draw—it's just a wing with a neck attached. Draw the curl.

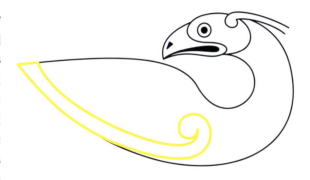

From the head of the curl, make a pair of bars that extend to the bird's back, as shown in blue. Create a second set of bars, parallel to the first, farther down the wing.

Past the blue bars, add some lines within the tip of the wing, as shown in red. These are the long wing feathers seen at the tip of the wing in the photo. The tail feathers are drawn in green. There is no set number of feathers that needs to be drawn, but three is a mystical number for the Celts, so it's a nice touch if there's room.

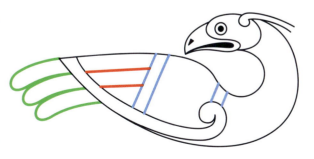

BIRDS

The Basic Bird...

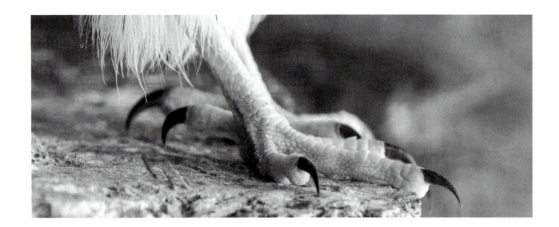

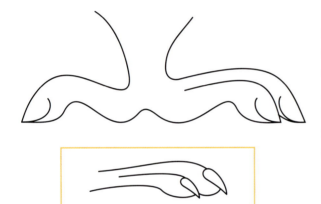

Now add the bird's leg(s) and foot. Draw a single foot or both feet, depending on how much space is available. The number of toes can also vary. Real birds have three forward-facing toes and one backward-facing toe. Always draw the backward-facing toe, and draw any number of forward-facing toes. The nails can be simple curves at the toe tip or be fully drawn nails, as shown in the insert to the left. Full nails usually appear more like talons or claws, so they are useful for distinguishing between types of birds.

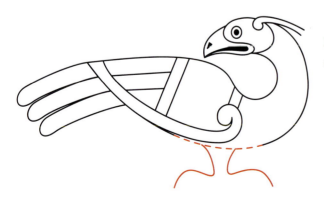

For this example, only draw one leg. To add the leg and foot, erase the bottom of the body and add a branching curve on either side.

Creating Celtic Animal Designs

The Basic Bird...

Make the curves on the bottom of the foot to divide the front and back toes. Fatten each toe at the tip so there's room to add toenails in any style.

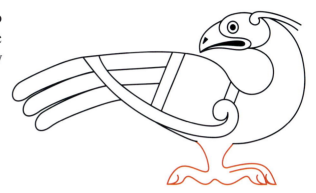

Now comes the fun part: adding the feathers and all their wonderful little details.

In the part of the wing by the shoulder, add rounded semicircle feathers. Each row of semicircles is staggered from the previous row. The number of feathers and rows that can fit is determined by how much room there is. Try some of the feather variations below, or mix and match!

The tail feathers extending from the tip of the wing can also be decorated. Any variation is acceptable, but try some of the traditional options below.

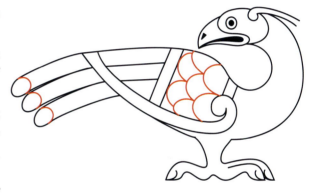

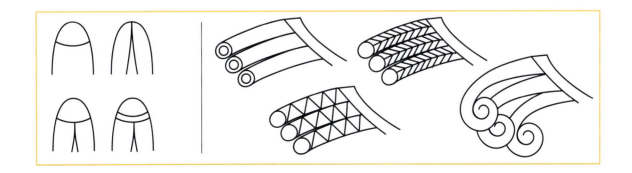

BIRDS

The Basic Bird...

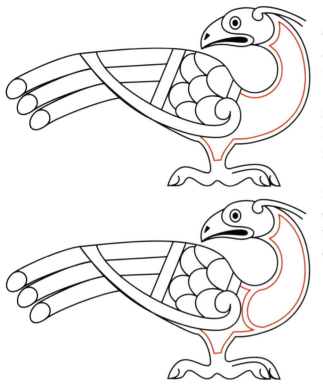

All Celtic animals are drawn with a double outline, as shown in red. The double outline is added just inside the main body outline and can be drawn close to the original line or far away.

On a bird, the double outline stops before the feet at about the thigh or ankle, depending on how long the leg is, and curves at the neck to follow the curve of the cheek.

A "collar" can be drawn at the base of the neck by the wing curl, as shown in the second example on the left. This divides the neck into two parts, which is convenient for making them different colors.

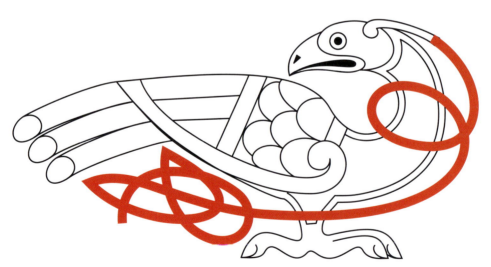

The last stage is weaving the bird's head crest. This is where freehand knotting comes into play. Each design is different because the freehand knotwork depends on the space around the design. In this example, there's a little loop around the neck that runs past the leg and loops around under the tail feathers.

Creating Celtic Animal Designs

The Basic Bird...

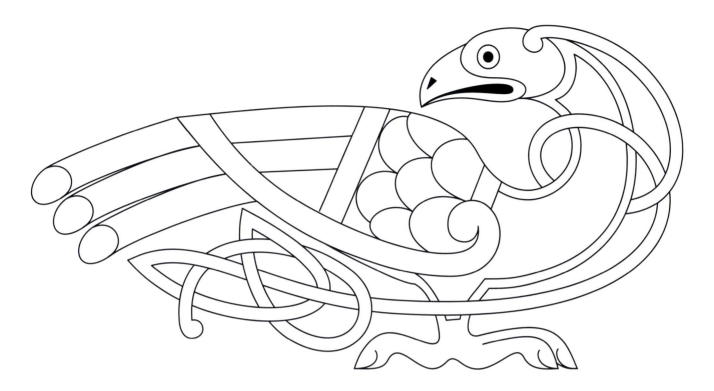

 For a general approach, begin with a rough sketch of the body position—add the larger elements, such as the head, feathers, tail, and feet—and weave.

 When drawing Celtic animals, be aware that the weaving rule (over/under, over/under) sometimes doesn't work out perfectly. Depending on how many toes, legs, or necks the knot must weave through, there might be an uneven number of components, and the weaving will need to be tweaked to work. This may mean adding an extra toe or adjusting the knot to weave it differently in order to maintain the over/under pattern as much as possible.

 In rare cases, there may be two overs or unders in a row. When part of a design would pass over the animal's face, make sure that the face is seen. In that instance, the face would be the "over" and the knotwork would pass under. This can be seen in the ancient manuscripts, so it is acceptable.

 The freehand knotting is done as demonstrated in the previous chapter. First the sketched line is expanded. Then anywhere the line intersects with itself or some part of the bird, it weaves over or under. Once the knotwork is woven, the design is complete!

BIRDS

༂ Creating Bird Designs

After learning how to draw a basic bird, try birds in various poses to fill different shapes and make larger designs. The combination of shapes and poses is infinite. Draw a pair of birds inside a triangle and a rectangular border, and examine the construction with both.

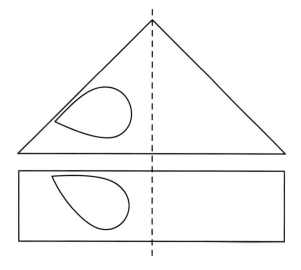

Begin by dividing the two shapes in half in order to make them symmetrical designs. Draw one bird in one half, and then mirror it to make a matching design on the other side.

Roughly sketch the bird's body as a teardrop shape. The body takes up the most space and determines which way the bird is facing and how he's sitting, so it's a great way to begin. Knowing that the rounded end will eventually have a neck and head added, be sure to leave some room between it and the center line. Also leave room on the bottom to add the feet.

Creating Celtic Animal Designs

Creating Bird Designs...

Add the neck, starting from the bottom of the body/wing and curving upward. In the triangle, the neck stops before the center line. In the rectangular border, the neck extends past the line, so when the bird is mirrored, the necks will weave.

There's more room in the border design, so there's space for both feet. The foot farthest from the viewer is usually extended forward. If both legs are drawn, the foot on the far side of the animal is usually the foot extended forward, while the foot closest to the viewer "kicks backward."

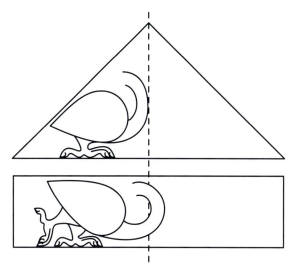

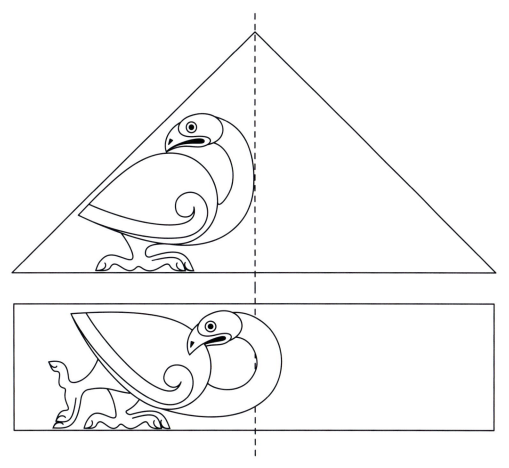

Begin filling in the details. Add a head, and draw in some of the wing details.

BIRDS

Creating Bird Designs...

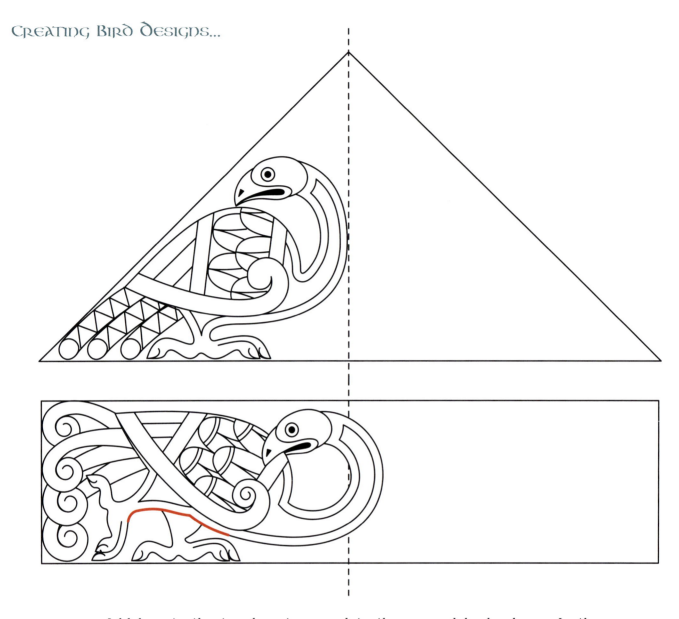

Add legs to the teardrop to complete the general body shape. In the rectangular border bird, notice that although the leg farthest from the viewer extends forward, the tummy is attached to the closest leg, as shown in red. This gives the bird the illusion of being 3D.

Finish the wings and tail feathers. These examples demonstrate the impact that simple style choices can have on the look and feel of the bird. Add a double outline to the body.

Creating Celtic Animal Designs

Creating Bird Designs...

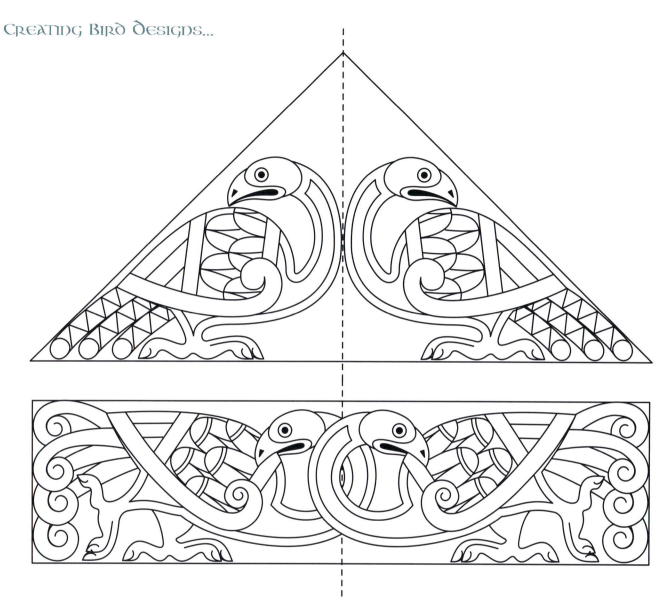

The design is almost done. It's time to add the head crest and weave some knots out of it. This fills the empty spaces left in the design. To get a better idea of how much room is left, mirror the image and examine the remaining spaces. Don't weave anything else until you're ready to weave everything, including feathers, feet, and head crests.

BIRDS

Creating Bird Designs...

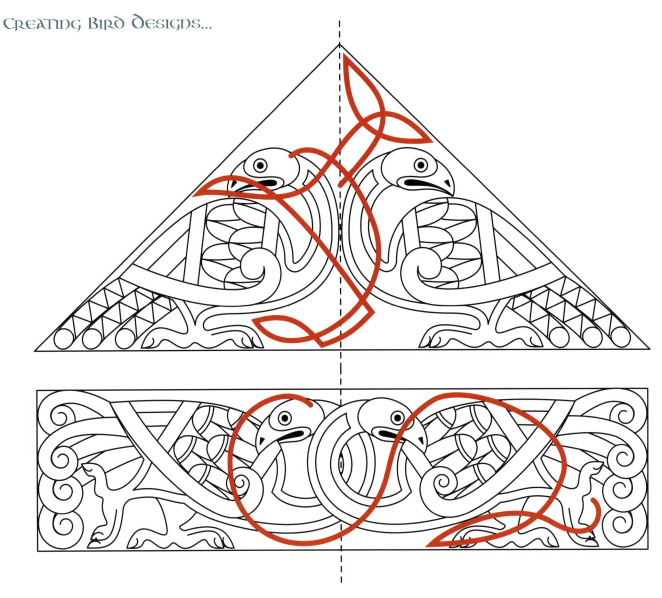

 The images are flipped above. Begin the head crest knotwork.

 Add the head crest, again working in one half to figure out the design before flipping it.

 Some of the weavings go over the birds' faces. Make sure that these occur in the mouth or beak area so that the bird can be biting the strand. Weavings don't always need to go through the mouth, but this can be a fun touch. Make sure that the strand doesn't cover the eye or too much of the face and that it's within the mouth area so that the bird can reach it.

Creating Celtic Animal Designs

Creating Bird Designs...

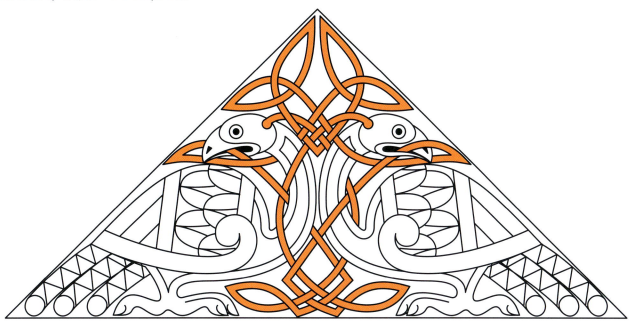

Try not to cover up too much of an animal's face. Covering a bit of the beak or muzzle is acceptable. Sometimes with the over/under of the knotwork, the bird on one side of the design might work okay but the bird on the opposite side has knotwork crossing over too much of the face. See the beak on the right above. The rest of the knotwork should weave in the over/under pattern as it crosses legs, necks, toes, and feathers.

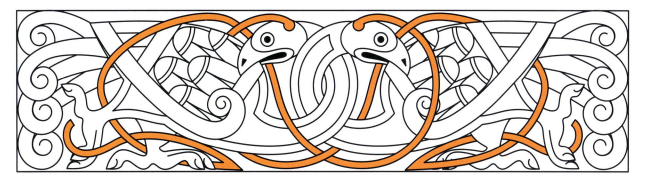

If the weaving passed over too much of the birds' faces, there are two solutions. Redraw the weaving so it doesn't pass over the face, and make it pass in a different place. Or "cheat" and pass both weavings under both faces, creating an incorrect under/under in the weavings. While not ideal, it's better to have the faces showing with a "cheat" than keep the weaving correct and cover the face. Animals in *The Book of Kells* show this cheat often.

BIRDS

CREATING BIRD DESIGNS...

The key rules for weaving animals, particularly birds, are:

Rule #1: If showing two legs, the leg farthest from the viewer is usually the one extended forward.
Rule #2: The face must always be showing.
Rule #3: If a weaving cannot be corrected or redrawn, it's best to leave the error in the head area and "cheat" the knotwork pattern.

⚄ BIRD VARIATIONS

It's easy to make variations. Change the shape of the beak, add different details to the feathers, make the toes small and dainty, or make the talons fierce—all these will change the overall look of the bird. The basic body components remain the same. The easiest way to create a new bird design is to make a "stand-alone" design first. Figure out the specific details using photos of birds for inspiration and guidance. Create the larger design with multiple birds or other animals. Block in the design with the teardrop bodies, add the necks and faces, and add knotwork or details to fill empty spaces.

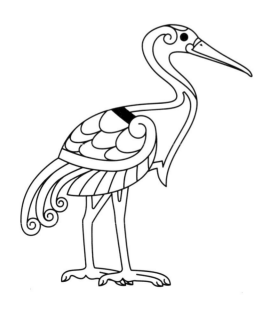

Celtic Heron: This design has all the signature elements of a real heron—long legs, narrow toes, and a long, slender beak. The neck is very narrow, so a double outline wouldn't fit, but a little curl keeps it from being plain. To imitate the heron's long, loose wing feathers, add an extra row and a tuft of feathers on the chest.

Creating Celtic Animal Designs

Bird Variations...

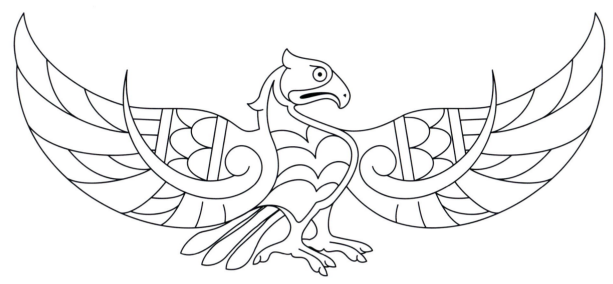

Celtic Eagle: This example uses a slightly different body shape, but the wing remains a teardrop filled with feather details. Extending the eagle's chest out and mirroring the wing on the other side gives him a proud and noble appearance. Add a hooked beak, a stern brow, and a few feather flairs at the back of the head.

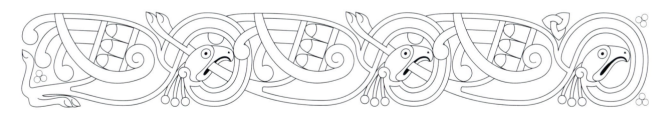

Extension of the Basic Design: Curling the bird's neck into a loop and stretching out the leg and toes creates an interlocking and repeating design. Each element still has the standard features: the teardrop wing and body, neck, head, and toes. Although the length of the neck and leg shown above aren't realistic compared to an actual bird, these exaggerations are acceptable in Celtic art.

BIRDS

BIRD VARIATIONS...

Not all bird designs have to weave and tangle. Adding Celtic elements to a basic animal form gives it a Celtic flavor. The owls to the left are variations on traditional bird designs.

A few options give the birds an owl-like appearance. Instead of a face in profile, the owl faces look directly at the viewer. There are fancy eyebrows and a different beak. The top owl has a wing almost exactly like the wings on the previous birds, whereas the bottom owl's wings are more extravagant.

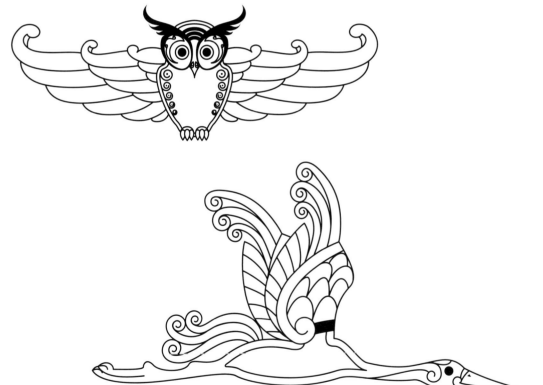

Draw birds in poses other than just standing. In the above example, the crane from earlier in this chapter changes into a flying crane. The individual elements are mostly the same, but the crane's leg and neck extend out and the wing turns and lifts up off the body.

Creating Celtic Animal Designs

Celtic Cranes © 2019

HOUNDS

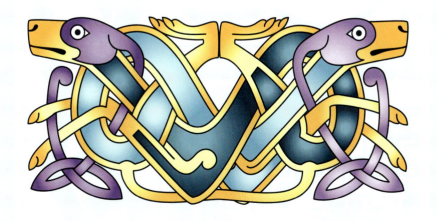

HOUNDS

~ The Basic hound

The Irish wolfhound is the dog used as a model in Celtic art. This dog is native to Ireland and is thought to be related to other hunting dogs like the Scottish deerhound and the Russian wolfhound. The Irish wolfhound is cherished for its size, loyalty, and ferocity. Long ago, the dogs were taken into battle and used to bring down game like wild boar. They're very large dogs, with a shaggy look. Noble yet friendly, these gentle giants provide lots of opportunities for Celtic hound designs ranging from fierce to playful!

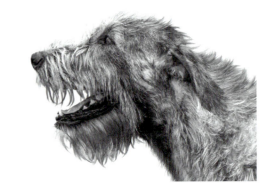
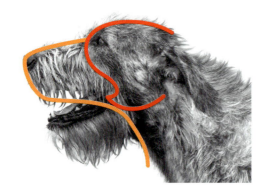

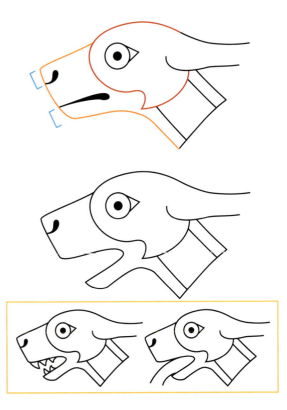

The Celtic hound has the same speech bubble face used for birds. The speech bubble divides the skull, shown in red, from the muzzle, shown in orange. The mouth is open in the photo above, but the Celtic version can be drawn either way. The orange line shows where the muzzle would be if the mouth were closed.

The muzzle is a roughly rectangular shape drawn from the "forehead" of the speech bubble. The eye sits in the front rounded part, and the nostril and mouth are longer curved shapes. The nostril and mouth connect to the edge of the face by approximately the same distance, as noted in blue above.

To draw a hound biting or snarling, open the mouth and add teeth or a tongue coming out.

Creating Celtic Animal Designs

The Basic hound...

To draw a hound head, begin with a speech bubble. Add a box nose for a muzzle. Vary the taper at the tip depending on the desired look. For a greyhound, draw a more tapered muzzle for a very slender nose. A boxer has a thicker, more squared-off nose. Any of these looks is acceptable. Just consider what look or personality the hound should have.

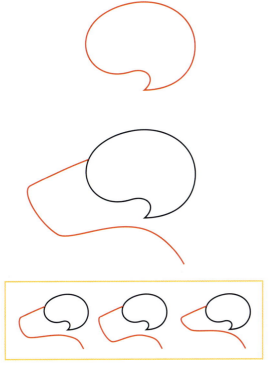

Add the eye, nostril, and mouth. The eye can be drawn with any of the variations used for the bird eye. The back of the neck attaches to the back of the speech bubble.

The top of the ear comes off the back of the head. The bottom of the ear starts with a little curve or curl, as shown in red.

Hounds almost always have long ears. If you see an animal with long ears in a Celtic manuscript, it's a hound! Lions are never drawn with long ears, so ears are a good way to tell hounds apart from lions.

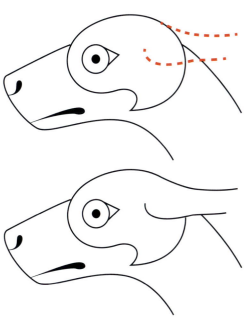

HOUNDS

The Basic hound...

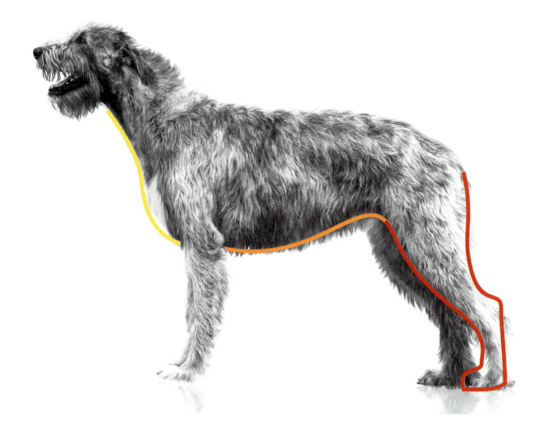

Examine the body of the Irish wolfhound. The back is fairly straight until it curves around the rear end. The back leg has a "drumstick" look, as shown in red. The thigh is thick and wide, and then the leg tapers around the knee and ankle. From there the leg continues straight down to the toes and foot.

The stomach, drawn in orange, is wider at the front where the ribs are. It narrows at the waist or loins, where it connects with the front thigh. The front leg is straight, except for the bend of the foot. The chest, in yellow, extends down from the throat to curve and, between the legs, connects with the belly.

The drawn hound will have all these elements, only in a simplified fashion. Celtic animals are easy to draw, even without a lot of drawing experience, because the goal is not hyperrealism.

Creating Celtic Animal Designs

The Basic hound...

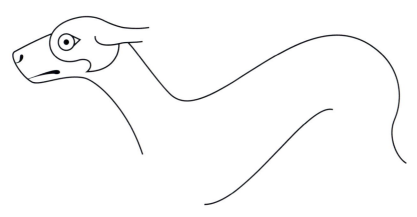

 Celtic hounds are drawn tangled up, leaping, or lying down. Any pose is acceptable. Usually Celtic animals have longer necks than their real counterparts, so begin with a long neck and a long back. In the photo, the dog's body curves after the rear end and dips in at the back of the thigh. Draw in the line for the stomach, making it wider where the ribs would be and then narrower at the loins. This line can be tweaked after adding the legs, so just sketch it roughly.

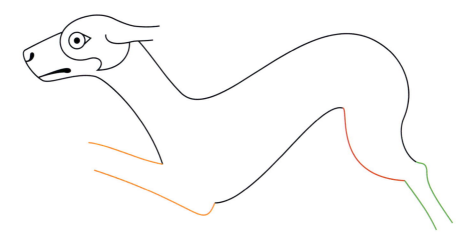

 Draw more of the back leg, keeping in mind the drumstick look—fat at the top, as drawn in red, and tapering in at the ankle and knee. The lower portion, shown in green, continues straight from the knee.
 The front leg begins with a little curve right on the belly, near the ribs, for the front elbow and continues straight out, as shown in orange.

HOUNDS

The Basic hound...

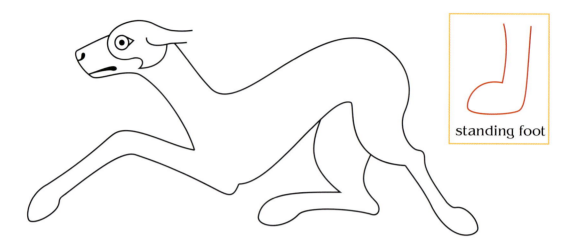

standing foot

Draw general shapes, like mittens, for the feet. The insert shows a plain, standing foot.

Hounds can be drawn with one leg in the front and one in the back or two legs in both the front and the back—or you can mix and match. In this example, the space under the belly can be filled by adding another leg. The front leg is bent forward as if the dog is taking a step before leaping. As with the bird, the stepping-forward foot is usually the foot farthest back from the viewer. The legs don't need to be equal in length, although in a simple pose like this, having the legs approximately equal in length looks more balanced.

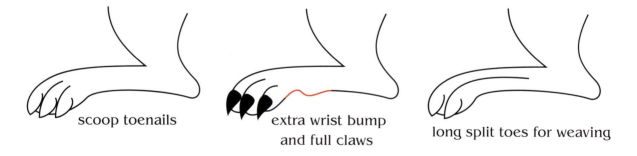

scoop toenails extra wrist bump and full claws long split toes for weaving

The foot can be drawn with different kinds of toenails or claws. Draw the toes and nails on top of the end of the mitten shape. If weaving knotwork through the toes, elongate them to leave more room. See the example on the right, with split toes. Make sure the front toenails match the back toenails.

Creating Celtic Animal Designs

The Basic hound...

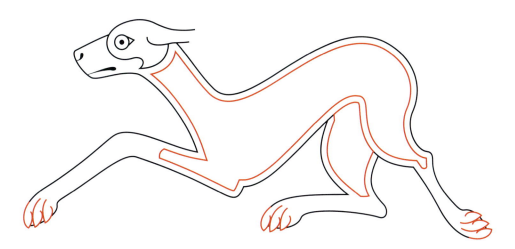

After adding toes and feet, draw the double outline inside the body. Stop short of the head, and end the outline partway down the legs, where the space begins to get too narrow.

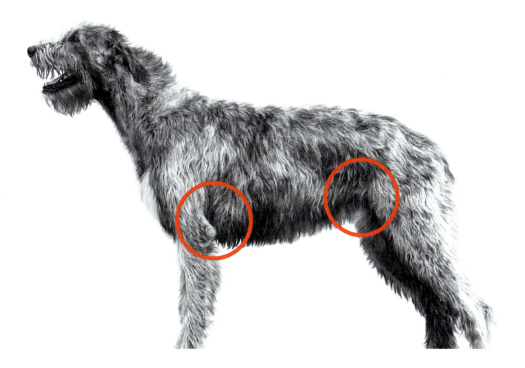

Where the legs join the body, a special curl is drawn to denote the joints circled in red. They can be drawn in the front or in both the front and back.

HOUNDS

The Basic hound...

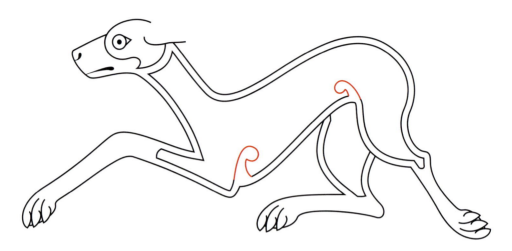

Above, the little curl or nub is in both spots. If there is a lot of room, turn the front leg nub into a full spiral design. The back leg nub is usually drawn in a simple manner or not at all.

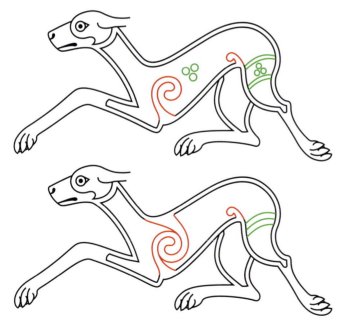

If the hound is speckled or brindle, add dots or stripes. Or add designs just to give extra decoration for coloring or detail. Add two or three stripes to the back thigh. Add Celtic triple dots around the body, as shown in green. Add spirals around the elbow or loins.

Creating Celtic Animal Designs

The Basic hound...

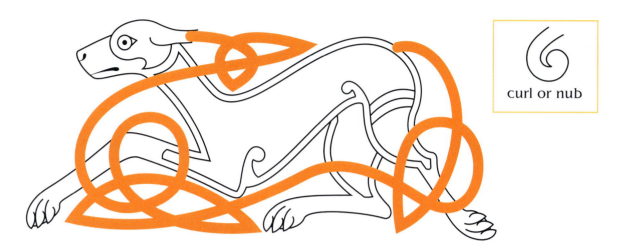

The remaining spaces can be filled with freehand knotting. The ear, tail, tongue, body, legs, and toes may weave. The hound can bite any weaving or body part—on his own body or another animal's. In the above example, the tail and ear are elongated into knotwork. They can end separately—usually in a little nub or curl, as in the insert—or they can connect to each other and make a continuous strand, as shown above.

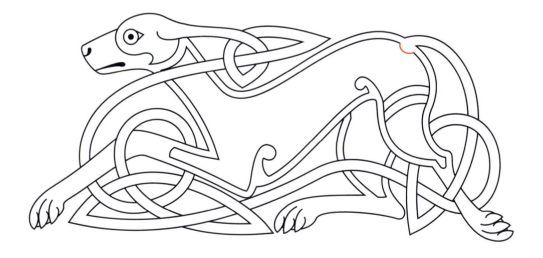

After weaving, the last step is attaching the tail to the body by adding a little scoop to the inside outlines around the rear end, as shown in red. Make a dimple where the tail joins the body.

41

HOUNDS

Creating hound designs

We've covered the basic hound, but what about a design where hounds or other animals are tangled up with each other? Let's go through an example from start to finish, brainstorming a process and then working the hounds into that shape. A million poses and combinations are possible, but this step-by-step guide breaks down the process into manageable parts.

Start with the shape that will be filled. A lot of Celtic designs are drawn in a circle, or "rundle." Begin by drawing a circle, and divide it into four sections. The quarter-circle on the left will be filled with two intertwined hounds. Start sketching in a hound in one half of the quarter-circle, and then flip it to get the final design. Below, the quarter-circle is divided in two.

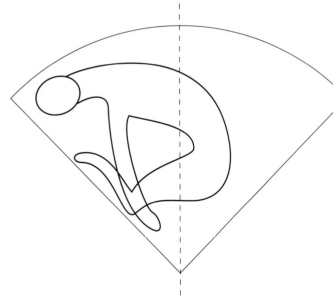

It's easier to see what's going on when the quarter-circle is upright.

Roughly sketch the dog body. Draw an egg shape for the head, leaving a bit of room above for the ear. Make a sausage shape for the body, curving past the center line and then coming back over to the left side, with rough back and front legs.

Creating Celtic Animal Designs

Creating hound designs...

In the test flip of the hound in red, there isn't enough room for the front legs. They're running over part of the body.

It's fine that the back legs pass over each other. As with knotwork weaving, two body parts may pass over each other and weave, but not more than two. There can be a leg over a body or a leg over a leg, but there can't be a front leg over a back leg over a body. That would mean too many things crossing in one place.

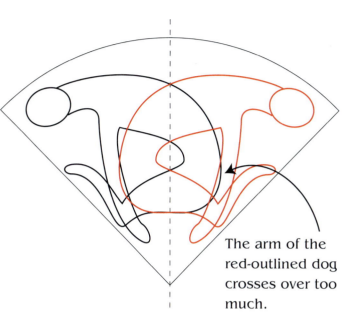

The arm of the red-outlined dog crosses over too much.

Move the hound's rear end toward the center line. Now the flip test shows that there's enough room for the front legs. A lot of work goes into creating Celtic animals, with all their details and body parts, so do the flip test to ensure that there is enough room for everything. This might mean scanning the work, flipping or mirroring it, readjusting it on paper, and scanning it again to do another test flip. Avoid adding unnecessary work. Check it when it's just a sketch before adding everything else.

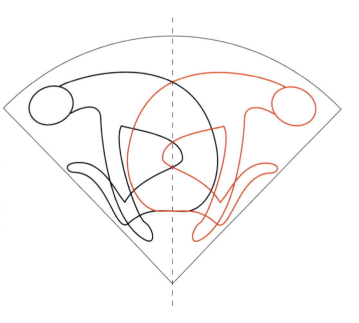

HOUNDS

Creating hound designs...

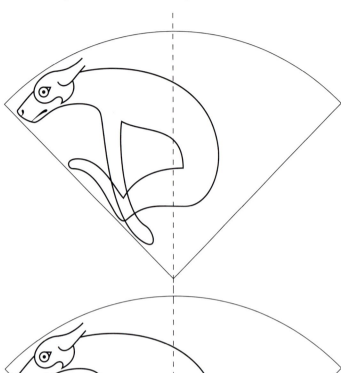

After confirming the body placement and shape, fine-tune the shape of the sausage body and add details. Reshape the back and neck, and add a face.

Draw the back leg and foot normally, with a mitten foot and toes. For the front leg, use the weaving-style toes ("split toes") in order to weave the front toes with the back toes during the weaving stage. Add a couple toes at the bottom of the foot, and then from one toenail extend a line up the leg, dividing it in half. Make sure that this line goes up past the other leg completely.

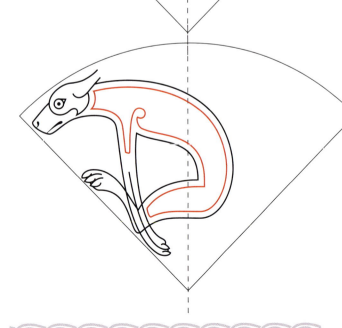

Add the double outline, including the little nub or curl where the front arm joins the body.

Creating Celtic Animal Designs

Creating hound designs...

Once the details are added, flip the dog and mirror the image in the other half. Because of the flip test, of course there's room for the dog to fit perfectly. Fill the gaps around the dogs with knotwork weavings. Don't weave any other body parts until after weaving the tails and ears.

Add the tail and ear weavings, making sure that only two things pass over each other in any given place.

In the above example, the tails weave a little knot and the ears weave a more complex knot. The tail was connected to the ears in the previous stand-alone example, but here they remain separate.

HOUNDS

Creating hound designs...

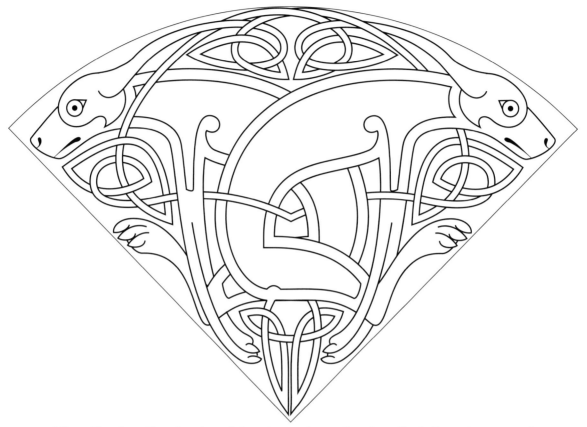

After flipping the freehand knots and confirming that there's room for them, weave them. This design is contained or isolated within its quarter-circle segment, but the next chapter covers connecting multiple segments together so that the entire design can be interwoven.

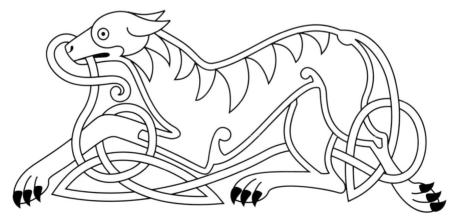

Experiment! Make a few alterations to give a hound the look of a wolf. Some zigzag curves along the back imply rough fur, and a tapered nose and claws suggest a fiercer appearance.

Creating Celtic Animal Designs

Hounds of Ulster © 2019

LIONS

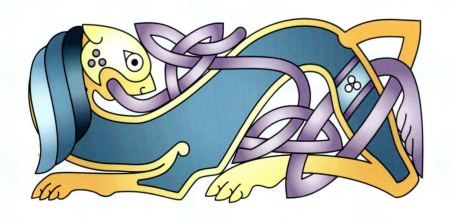

LIONS

The Basic Lion

At the time of the ancient Celts, the European lion was a large predator. European lions died out in approximately 100 CE. According to skeletal remains, their closest modern relatives are African lions, so they are a good place to start for Celtic lions. African lions were brought up to Rome for gladiatorial games, so they were likely the inspiration for the lions in manuscripts like *The Book of Kells* and *The Lindisfarne Gospels*.

In the below photo of a female lion, the general body shape is very similar to the hound's. Besides the mane (for a male lion), tail, and face, the body has the same posture and characteristics as the hound's. Let's focus on the differences.

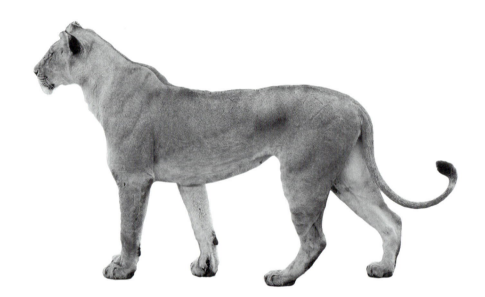

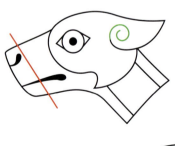

The lion head starts out the same as the hound's. A lion's muzzle is shorter. Let's take the hound example and trim it at the red line. The short ear doesn't elongate or weave. Inside the ear, draw a fun, little curl.

After shortening the muzzle, the face looks much more cat-like. The lion nostril is fancier, drawn as a tight curl in orange. Draw an eyebrow, as shown in green in the image on the left.

Creating Celtic Animal Designs

The Basic Lion...

The ear can face backward or forward, and a second ear can be drawn.

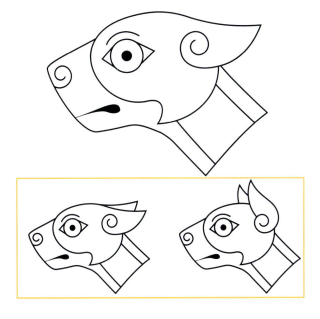

A lion is usually roaring or biting, and often the tongue is hanging out. Keep the mouth open, and add a tongue. A tongue comes in handy for knotting if there's room and can even be connected to the tail. A simple tongue has a nub end. The lion can be drawn with or without teeth and with or without a tongue.

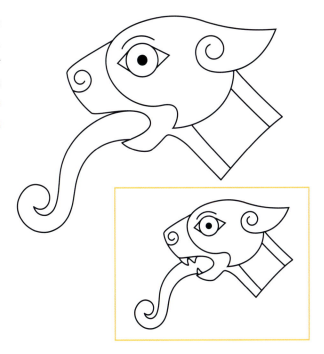

LIONS

The Basic Lion...

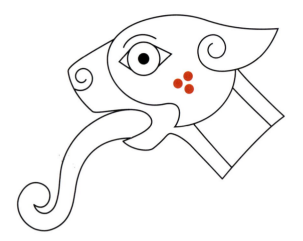

Whiskers are usually drawn as a set of triple dots. They sit on the cheek below and back from the eye, as shown in red.

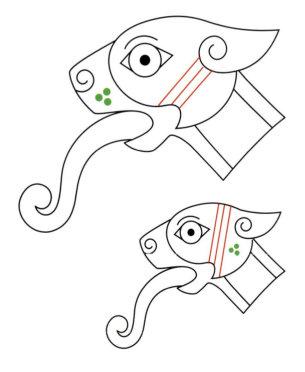

Another option for whiskers and facial decoration is adding stripes to the cheek and adding triple dots under the nostril. Vary the angle and position of the stripes depending on how much room there is. These stripes will be different colors in the final artwork, for added detail and interest.

Creating Celtic Animal Designs

The Basic Lion...

The photo on the right shows a male lion with a glorious mane. The mane sweeps off his forehead and extends down the neck to the shoulders. A smaller ruff, circled in yellow, comes out from the cheek area and blends in with the primary mane. Either add the "cheek ruff" or just do the primary mane, depending on how much space there is and how much detail will be in the finished design.

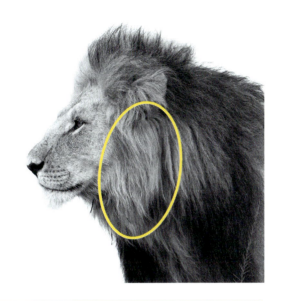

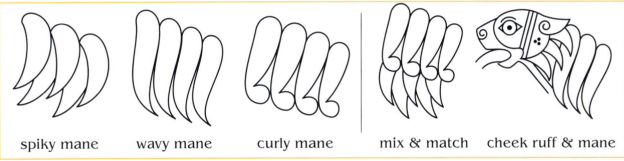

spiky mane wavy mane curly mane mix & match cheek ruff & mane

Above are the three primary mane styles: a spiky mane (jagged lines), a wavy mane (sweeping lines), and a curly mane (with the nubs on the ends). The mane can be drawn using just one style, or mix and match! How elements are layered or combined affects the character of the lion, as shown in the examples below.

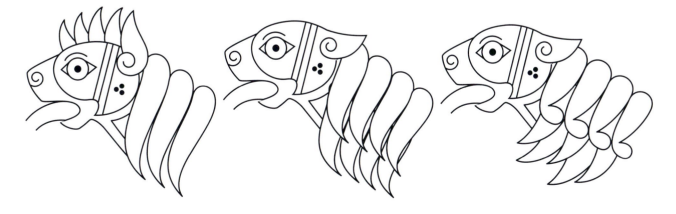

LIONS

The Basic Lion...

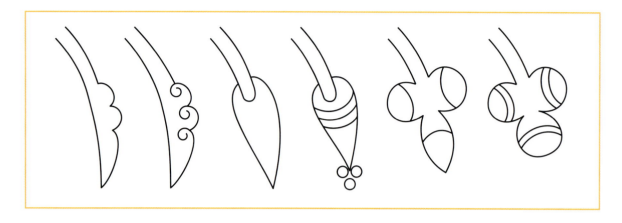

Above are some of the typical ways to draw the end of a Celtic lion's tail. Feel free to mix and match!

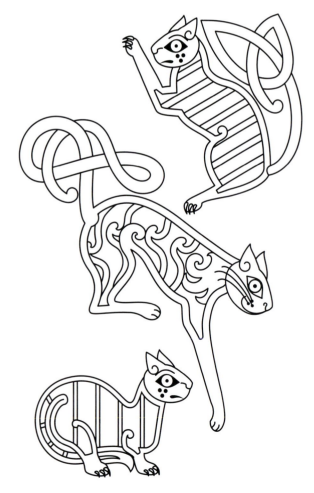

A lion can easily be transformed into a house cat. Cats were not uncommon in the ancient manuscripts, often chasing mice in the margins of the pages. One manuscript even includes a poem about Pangur Ban, a monk's cat!

To create a cat, use the same body form, but remove some of the "fierce" elements. Give the cat a friendlier appearance with no mane or ruff, smaller ears, and a smaller, rounded muzzle. Draw simple "mitten" feet with or without claws, and the tail is freehand knotwork around the cat. The manuscript cats are often drawn with stripes, like a tabby cat, but experiment with spots or curls for a calico or long-haired appearance.

Creating Celtic Animal Designs

૭ Creating Lion Designs

Start with a generalized shape. Divide a circle into three segments. Rough in the general body shape within one of the segments. Parts of the legs hang into the neighboring segment, so when it's rotated in a circle, the legs in one segment will weave with legs in the next segment.

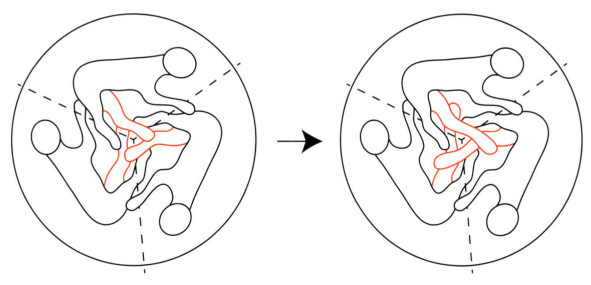

Rotate the test design to see how it looks overall. The far back legs, in red in the left image above, show some potential for weaving together if they're drawn a little longer. In the version on the right, those legs are longer. Other body parts have adequate space and don't have any difficult overlaps, so this sketch works for the final design.

LIONS

Creating Lion Designs...

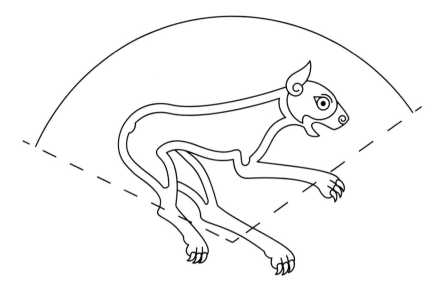

Add details to the lion. As the design takes form, if something looks too bare, add extra decoration—stripes, dots, etc. In the above example, the muzzle and face are drawn, as are the feet and claws. Notice the inner outline as well.

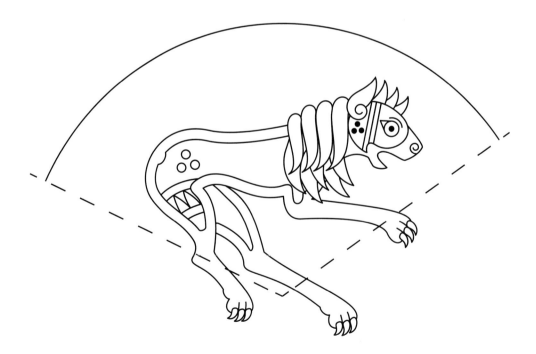

Keep adding details, until most of the body and design are complete.

Creating Celtic Animal Designs

Creating Lion Designs...

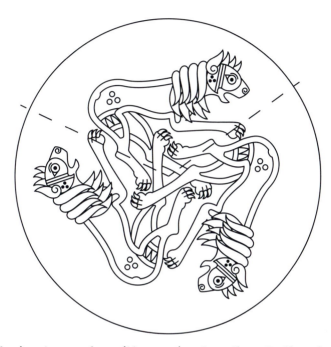

Rotate the design to see how it's coming together. In the above example, the center space is now filled with the lion's legs. This leaves the outer portion of the circle to fill with the tongue and tail weavings.

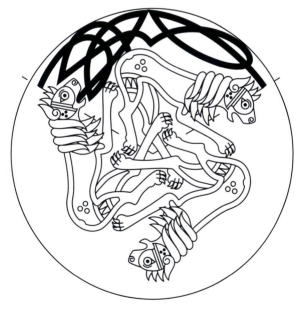

Doodle some freehand knotwork in the open areas. Adjust the segment lines that divide the circle into thirds so that it is centered relative to the empty space that needs to be filled. This illuminates the remaining space available.

LIONS

Creating Lion Designs...

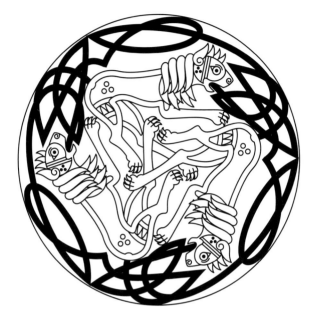

Rotate the knotwork to check how the overall design looks.

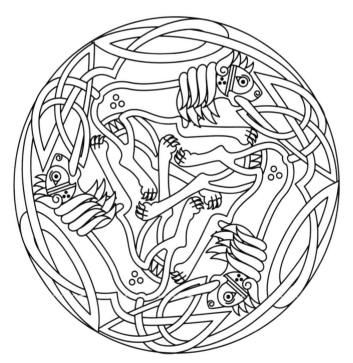

Finally, weave the knotwork. Vary the thickness of the knotwork lines to make the design more interesting. Make some parts thicker around curves. This is an easy way to improve a design and give it more personality than just a single line thickness for all the knotwork.

Creating Celtic Animal Designs

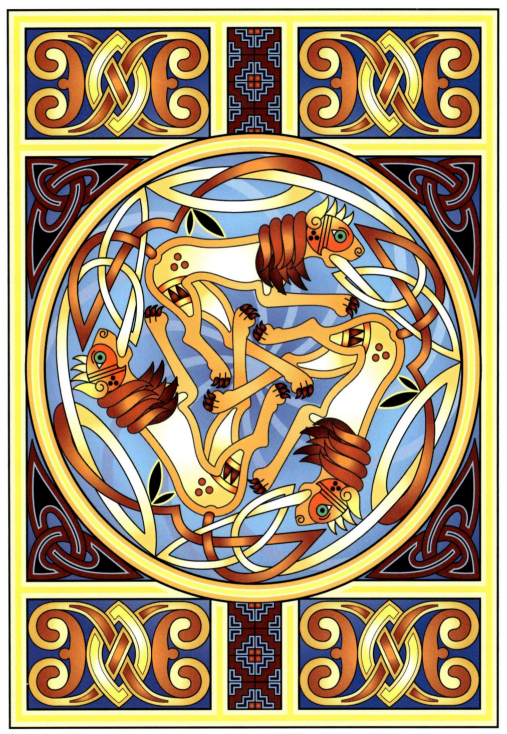

Lions of Summer © 2019

HARES

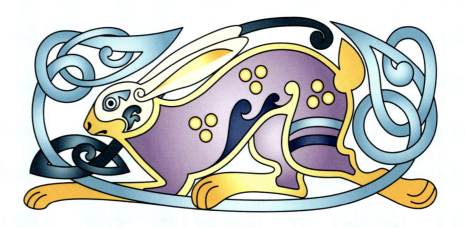

The Basic Hare

Rabbits and hares are not often seen in Celtic art, but there are a few examples in the old manuscripts. While not one of the main four animals (lion, hound, bird, and snake), a rabbit or hare is a fun and easy animal to draw in the Celtic style.

The brown hare is native to Europe and one of the largest hare species. Because a female hare can have three or four young per litter and up to three litters per year, the hare is a symbol of fertility in many cultures. As the hare was a common animal in Europe at the time of the Celts, it's a good example to use.

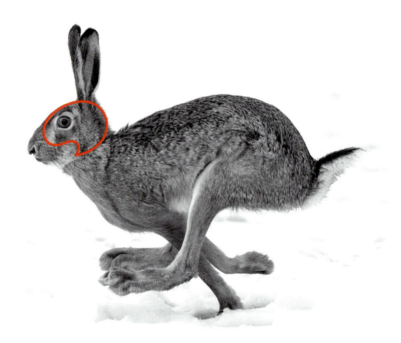

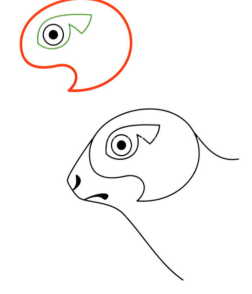

As shown in the photo, the face can be drawn in the speech bubble shape. Notice the white markings around the eye. They add extra interesting detail.

The hare has a smaller muzzle compared to the hound and the lion. The nose and the mouth are essentially the same but also smaller.

Creating Celtic Animal Designs

The Basic Hare...

Hares are known for their cute, little, rounded cheeks, so find a way to add or imply them. While there isn't much room in the muzzle, add some curly nubs to the cheek area of the speech bubble. This accents the rounded cheeks and suggests fluffy fur. The curly nubs are smaller than the lion's cheek ruffs but still add extra interest.

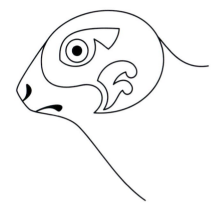

Add tall ears. For the ear closest to the viewer, draw a little curl at the bottom, where the ear joins the head. Add a line inside to imply a center crease in the ear.

Because ears are so important to the appearance of a hare, include both of them. Don't draw the inner crease on the second ear because it'd be facing away from the viewer.

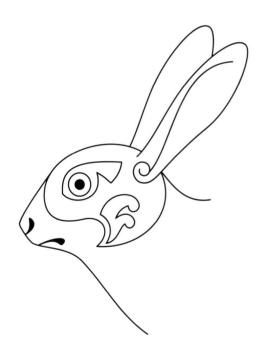

HARES

The Basic hare...

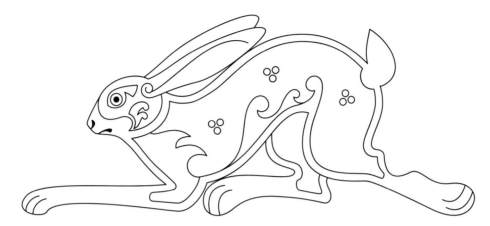

The body has the same design elements and rules that the hound and lion had, with some slight changes. The tail is a simple, upturned bit of fluff. The feet and toes are fatter and larger. Inside the design, add some curls around the chest and belly to imply fluffy fur. The dots could just be extra details, or they could suggest spots in the hare's fur.

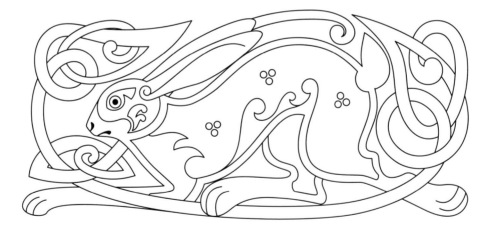

Unless the ears are extended, there isn't as much to weave on a hare. Add freehand knotwork as separate designs to weave around the hare. Weaving the ears might obscure them and make it hard to tell that he's a hare. Weaving the ears is still an option, though, and the knotwork is woven up the same as in previous chapters.

Creating Celtic Animal Designs

Creating Hare Designs

Let's move on to a bigger hare design in a circle. By rough sketching, doodle three general hare shapes running in a circle. This layout isn't too bad, except that it leaves a big hole in the center and the hares are only woven together using their legs.

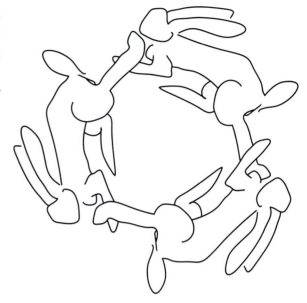

In this version, the front and back legs are extended toward each other as the hare leaps, much like the brown hare in the original photo. This design fills the central space better, but that's the only place where the hares are intertwined.

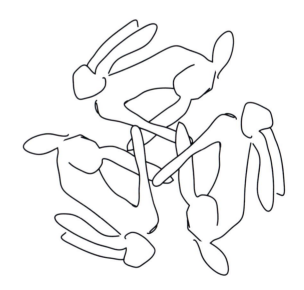

HARES

Creating hare designs...

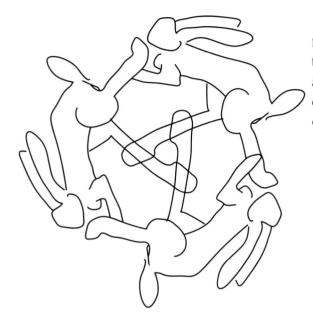

This variation has front and back feet weaving from hare to hare, and the back feet extend into the center hole and weave as well. The hares have a very dynamic feel to them, like they're jumping or leaping, and the pose fills the area well. Let's continue working with this layout.

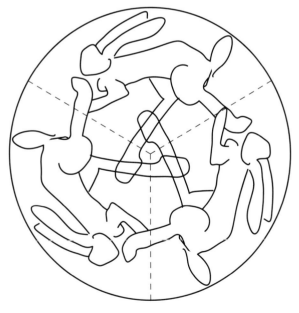

Develop the rough sketch into the final design. There are three hares in a circle, so divide the circle into thirds in order to know how much room there is for each hare.

Creating Celtic Animal Designs

Creating hare designs...

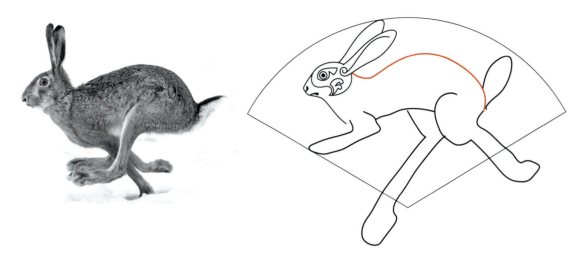

The head is based on the face in the stand-alone design. Beginning with the neck and back, smooth out the rough sketch and transform it into the final design. Referring to the original hare photo, draw a similar curved line for the back.

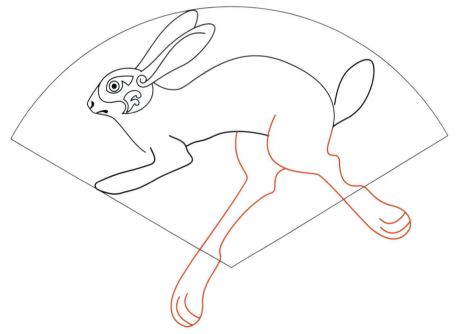

Replace the sketched back legs with proper ones. The back leg that's farthest from the viewer—kicking into the center of the circle—is longer than the other leg so that it can reach the center and be woven. This is normal with Celtic animals. They're often drawn with distorted or elongated body parts.

HARES

Creating hare designs...

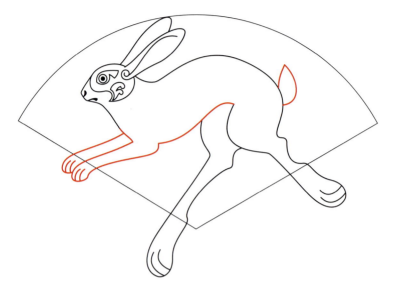

Add the belly, curving up at the loins and then dipping down over the ribs, where it joins the front legs. Add the tail.

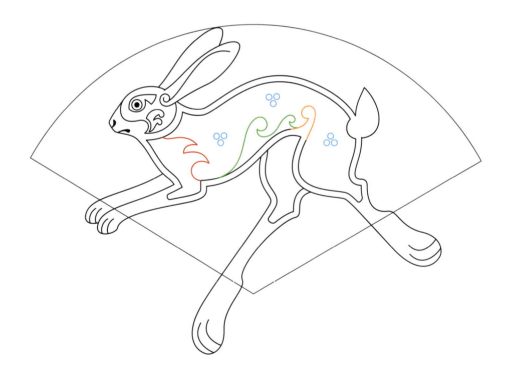

Add some internal designs to represent the hare's fluffiness and markings.

Creating Celtic Animal Designs

Creating hare designs...

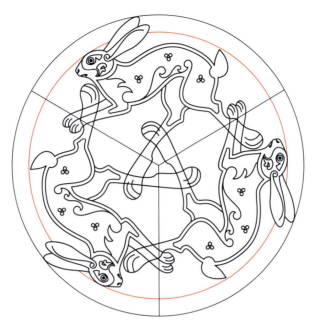

Rotate the sketch to see how the design is coming together. While the ears could be woven, they look good sticking out farther than the rest of the rabbit. If they are elongated and then woven into the bodies more, they "blend" into the rest of the design and won't stand out.

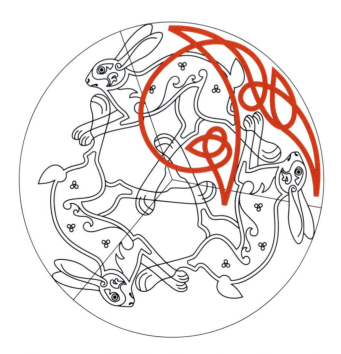

Again rotate the segment dividers to center on the empty space that the freehand knotwork needs to fill. Add some doodles to fill the empty spaces.

HARES

Creating hare designs...

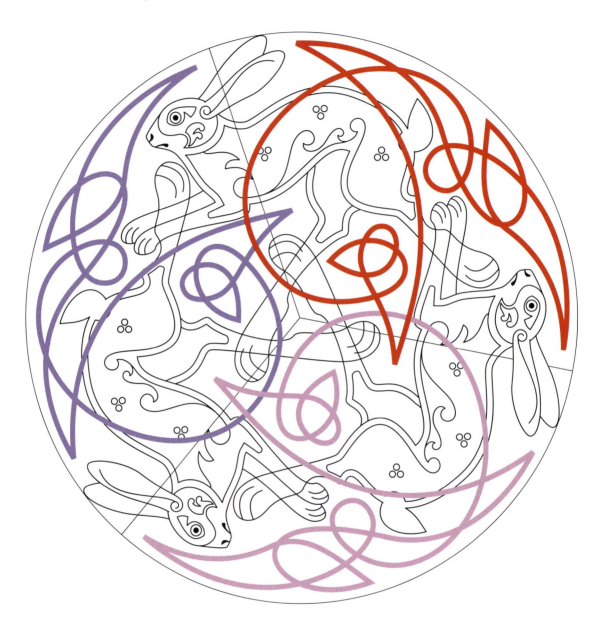

Rotate the design occasionally to test how the knotwork will look when the design is complete. Each separate portion of the freehand knotwork is a different color, so notice how each will fill the overall design. When all the spaces are filled, expand the knotwork and weave it through the design.

Creating Celtic Animal Designs

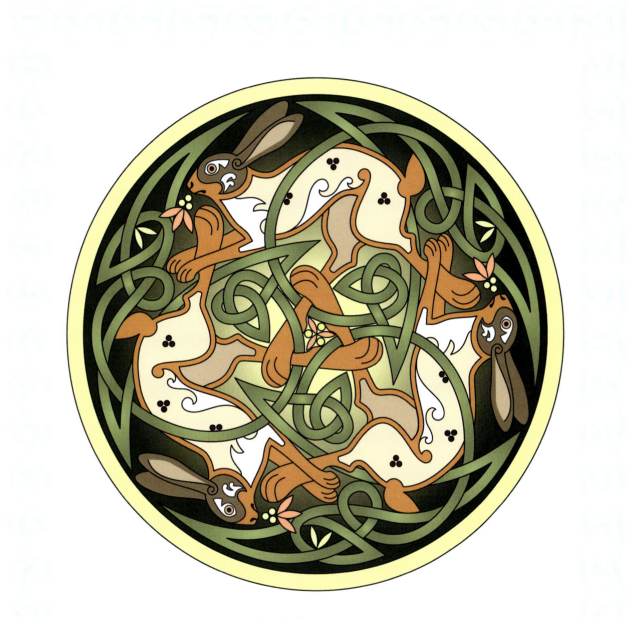

The Spring Hare © 2019

HORSES

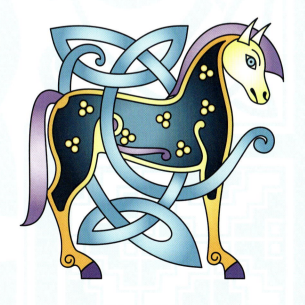

HORSES

The Basic Horse

The Irish horse, which arrived in Ireland almost 2,000 years ago, was bred with Anglo-Saxon and Norman war horses. They became known for their good nature and ease of training. Horses are fairly straightforward animals to draw, but interesting elements can be added, including manes, tails, coat markings, and woven legs.

In the photo, notice that the general body shape is similar to the body shapes in earlier chapters. Some obvious differences are the mane, tail, head shape, and longer neck. The back, curve of the rear end, drumstick back leg, belly, straight legs, and moderately rounded chest leading up to the neck are similar to those found in other animals.

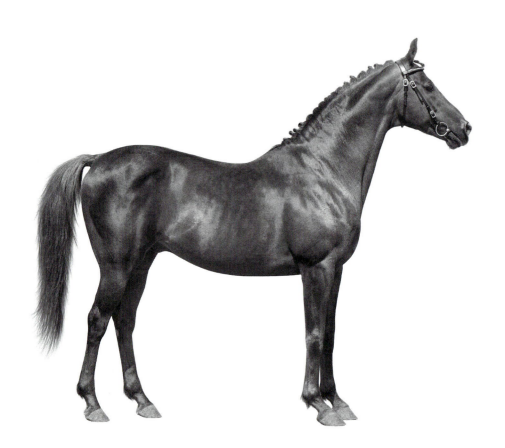

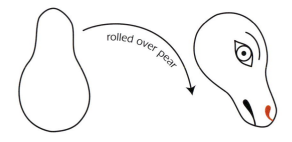

There is no speech bubble for a Celtic horse head. A horse head looks like a big pear tipped over on its side.

Creating Celtic Animal Designs

The Basic Horse...

Once the pear shape is tipped over, add the facial features. The eye is usually drawn with double triangles on both sides and sits in the fuller part of the "pear," a little toward the top. It's usually accompanied by an eyebrow. The nostril can be drawn as a curl, a teardrop freely floated in the nose area, or a slender, backward "S" shape.

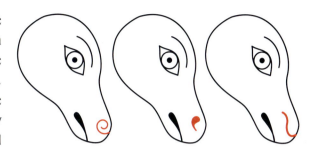

The pear shape is easy to draw, but for a more natural-looking horse, flare out the tip of the nose a bit, as shown in red. This, along with the free-floating teardrop nostril, gives a nice, natural look, as shown in the insert.

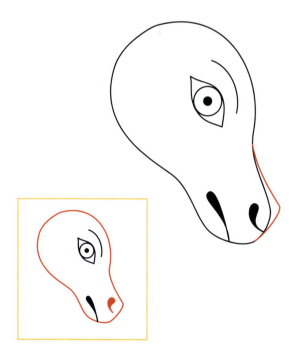

HORSES

The Basic Horse...

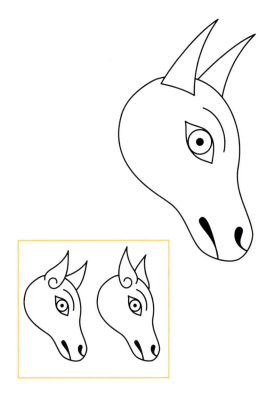

Horses' ears are tall and fairly large. They are often drawn in pairs and can face forward or backward. At their simplest they're triangular, but they can also be shaped like lions' ears, as shown in the left insert.

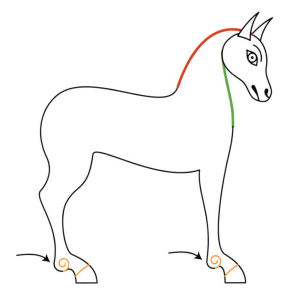

On a Celtic horse, the neck leaves the back of the pear-shaped head, as shown in red. The bottom part of the neck comes up to the cheek, as shown in green.

From the back of the neck, the body is shaped a lot like the hound and lion bodies. It goes down the back and over and around the rear end. Draw a drumstick thigh and long, skinny legs.

Notice that the ankles are emphasized by bumps, as shown with arrows. Draw little hooves. Add curls inside the ankle bones to suggest the fetlock tufts of hair.

Creating Celtic Animal Designs

The Basic Horse...

The horse can be drawn with two legs, as in the previous example, or three or four. Some horses in the manuscripts have bent legs, as in this example based on a horse in *The Book of Kells*. Alternatively, leave the legs straight and add knotwork instead.

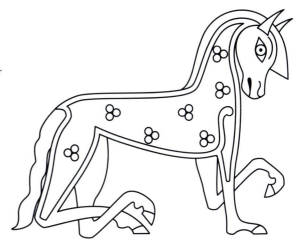

Add the double outline and then the inner nubs and curls. Make the nub by the front leg a little longer to give the impression of curvier muscles. For a dapple, pinto, or paint horse, add the triple dots all over the body for more decoration.

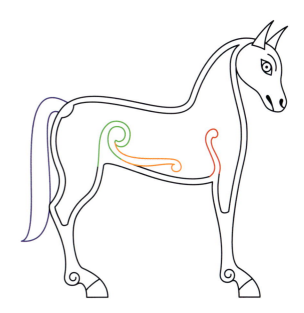

HORSES

The basic horse...

The tail and the mane personalize the horse and give it some flourish. Try some of the variations above, or make some up! In the example on the left, the rear end shape is different, with a little peak for the tail to emerge from.

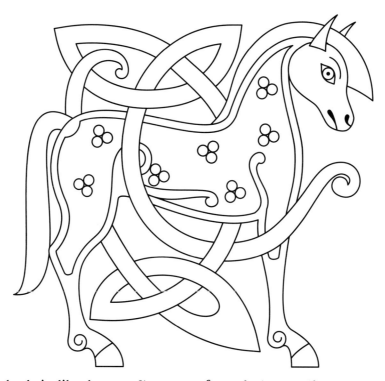

The forelock is like bangs. It comes from between the ears and hangs over the face on the forehead. The mane runs down the neck.
Add freehand knotwork, and weave it through the body and legs.

Creating Celtic Animal Designs

The basic horse...

As with the lion, there are a lot of variations for the mane. Try to have the mane, forelock, and tail match.

Creating Horse Designs

Map out the larger horse design by roughing in the basic horse shape. Working again in a classic circle divided in three, notice that the large horse body shape and legs cause a lot of overlap. While the designs should be woven together, enough of the bodies should be seen to identify the animal.

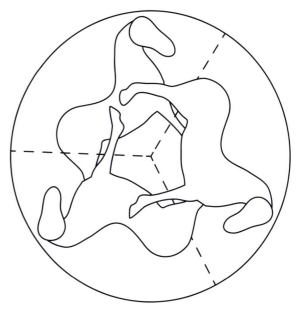

HORSES

Creating horse designs...

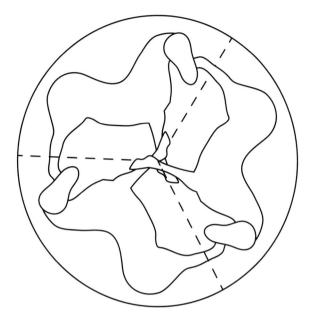

If the horse shape is angled, the legs and bodies are separated more. There are some interesting possibilities with the way that the three front legs meet in the center.

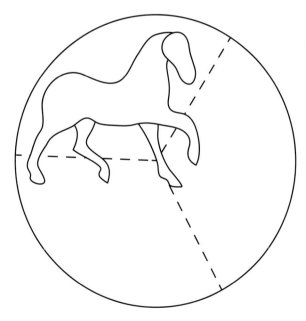

To change the design a little, switch the pose. Add the other two legs, and bend them as if the horse is walking.

Creating Celtic Animal Designs

Creating horse designs...

Rotate the horse, and make sure all the parts fit. The new leg positions fill the empty spaces better. If necessary, adjust them slightly so that they're not overlapping in the final body shape.

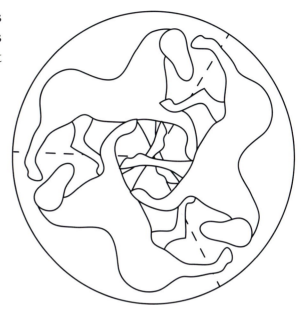

Flesh out the horse details, choosing a matching mane, tail, and forelock.

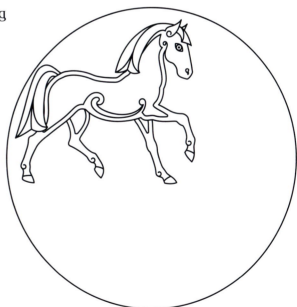

HORSES

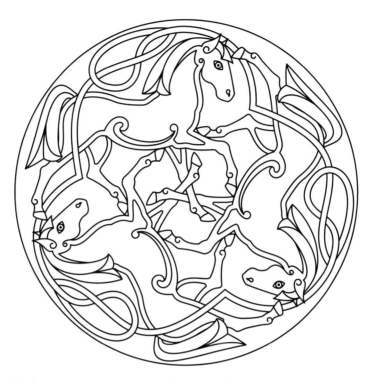

Rotate the finished horse, and begin weaving. Add some simple knotwork to fill in the empty spaces, and weave the legs as they cross in the center. In this variation on the design, join the pear head and the body together, and then add a little curl to the cheek.

Experiment with different poses! Bend both front legs and straighten the back to make the horse rear up! Add a different mane and tail, making sure they match.

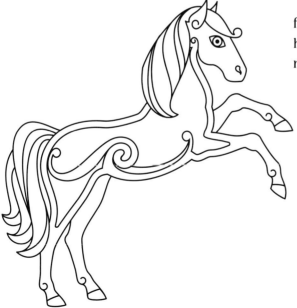

Creating Celtic Animal Designs

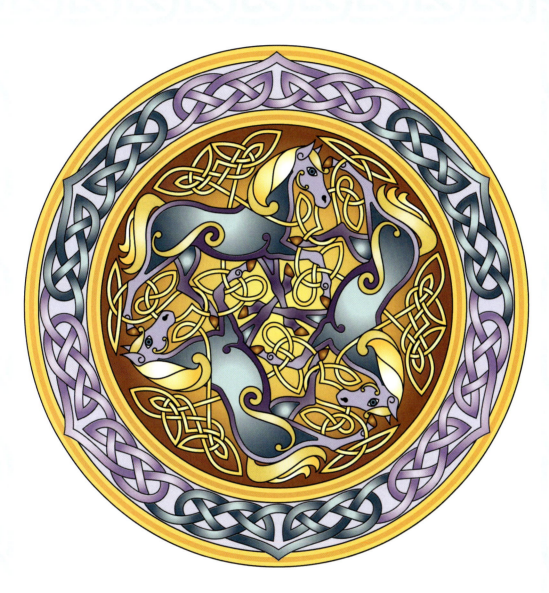

Epona's Shield © 2005

SNAKES

SNAKES

The Basic Snake

Compare the below photo of a real snake and a drawing of a Celtic snake. The snake is an unusual Celtic animal because it's usually drawn with a long "tail" or strands coming from the back of its eyes, as shown in red. These strands are drawn very fine and create delicate filigree knotwork woven in and around the snake.

Ireland has no native snake species. The land bridge joining Ireland to Britain was likely submerged under the ocean before the end of the last ice age, so the island was already cut off from other land before snakes could cross over. Snakes native to Great Britain include the smooth snake, venomous adder, and grass snake. Let's use the venomous adder as an example. It has some nice markings, and because Irish monks traveled to Britain frequently, they would have seen these snakes. Legend has it that the reason why there are no snakes in Ireland is because St. Patrick chased them out in the fifth century CE.

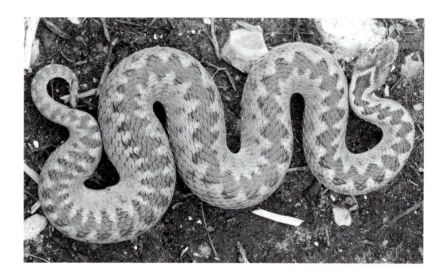
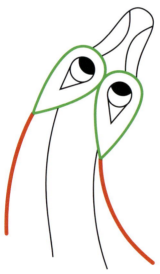

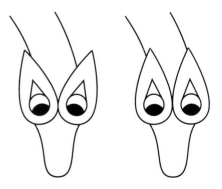

Snakes are drawn with large, teardrop-shaped eyes. The eyes sit a little bit back on the head. This allows the snout to taper from the eyes so that it has a slight waist or hourglass effect. The eyes should touch or be very close in the middle. They can either turn outward, as seen on the snake on the left, or lie straight back on the head so that they run parallel with the head/body, as seen on the snake on the right.

Creating Celtic Animal Designs

The Basic Snake...

The real snake has markings like a "V" coming from the nose and then curving around the eye sockets. The eyeball is in the rounded part of the teardrop. The eyes can have a triangle on the back going into the taper of the teardrop, but they should never have two triangles.

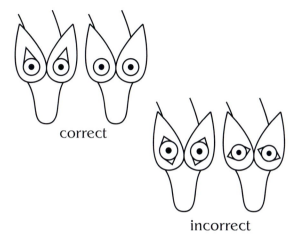

The nose slightly tapers and is at least as long as the eye teardrop. It can be decorated inside to add some detail. Here are some examples of common nose decorations to try. Continue these markings down the body, or change them up so that the nose is a little different.

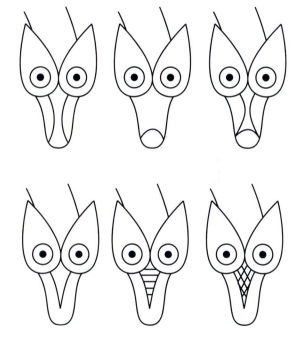

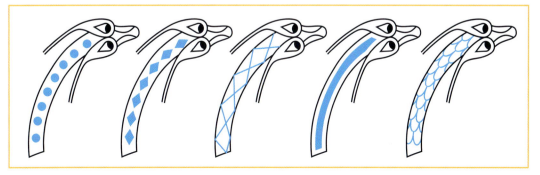

SNAKES

The Basic Snake...

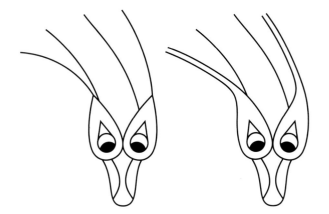

The strands coming from the eyes are typically very thin.

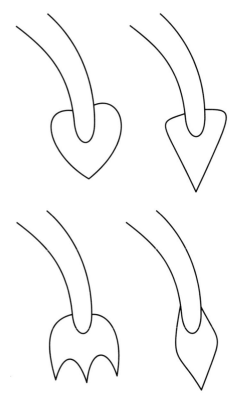

The tail usually has a spiky or pointy look. Here are some traditional tail designs, but feel free to vary them.

Creating Celtic Animal Designs

ᛏ Creating Snake Designs

Snake bodies are just long, skinny strands—much like freehand knots are. Convert a freehand knot into a Celtic snake design! Make a freehand design, and erase part of it—usually in the center or a corner, so that the design looks symmetrical. Try a few places and see where it looks best. A point or corner usually works well.

To follow the example on the right, erase the top point of a freehanded knot design.

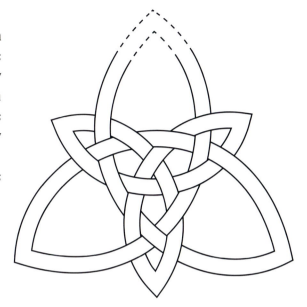

Add the head to one side of the knotwork.

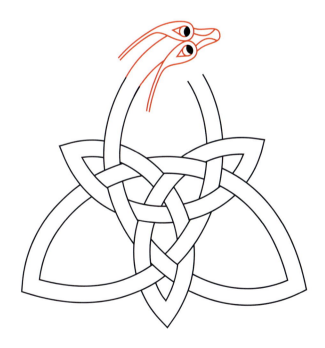

SNAKES

Creating Snake Designs...

Add the tail to the end of the other half of the strand. Curl the tail under the snake's chin into the empty spot, or extend the tail outward. Because the tail has just come from an "under" in the main knot, tuck the tail over the neck of the snake. Leave the skinny strands on the eyes to extend out over the tail.

Add diamonds, dots, stripes, or curved scales as body decorations.

Add the narrow eye strands, and weave them into the design. Fatten up the thin eye strands at the bottom of the design.

The finished painting on the right features a freehanded knot and a snake head. Extra spaces around the design are filled with more freehand knots.

Creating Celtic Animal Designs

Brighid's Serpents © 2019

fish

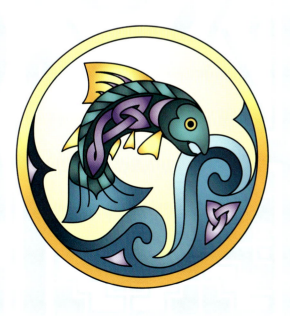

FISH

◊ The Basic Fish

A Celtic fish, specifically a salmon, is easy to draw. The salmon in Irish folklore was likely the Atlantic salmon, which is a native fish in Ireland. Feel free to experiment with other types of fish.

Irish mythology is divided into four major folklore periods: the Mythological Cycle, the Fenian Cycle, the Ulster Cycle, and the Historical Cycle. The salmon is a key animal in Irish folklore, figuring prominently in Salmon of Knowledge myths in the Fenian Cycle. In the story, a salmon ate nine hazelnuts that had fallen into the Well of Wisdom and was granted all the world's knowledge. According to the myth, whoever caught the salmon would gain all the knowledge the salmon had been imparted. As a boy, Fionn mac Cumhaill accidentally ate the salmon and was granted great wisdom, and he became a central hero of Irish myths.

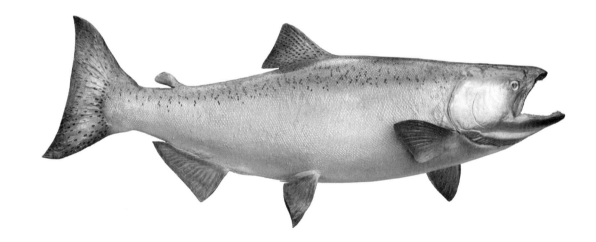

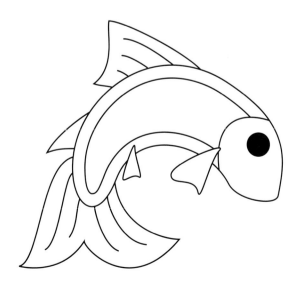

The above example shows a Chinook or king salmon. Notice that the body is essentially an oblong shape that tapers slightly at each end. The salmon has a very distinctive cheek area around the gills, multiple fins, and a tail. There are many spots across the body.

For a Celtic version, many of these elements are easy to do. To the left is a very simple version of how a salmon could be rendered in the Celtic style.

Creating Celtic Animal Designs

The Basic Fish...

Decoration can be done in a number of different ways, so experiment! Spots to resemble a real salmon, a herringbone pattern, or even some simple knotwork could fill the body shape with more interesting elements.

Add some more details to make the salmon more realistic. On the right, all the fins found on a real fish are drawn. The mouth is added with the little curved lips seen in the original photo. A slightly different cheek suggests gills.

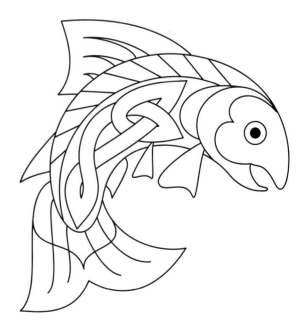

FISH

The Basic Fish...

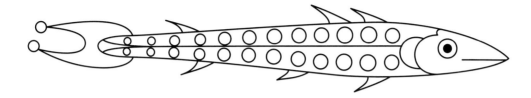

This salmon is a variation on a fish from *The Book of Kells*. It's a very simple body shape with simple Celtic elements added for decoration. While the previous fish were curved as if they were leaping out of water, this variation is drawn straight as if the fish is swimming through the water.

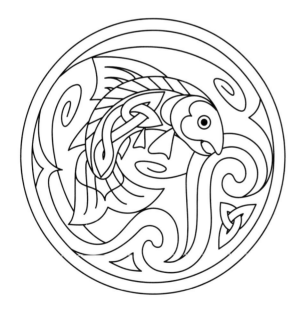

It is difficult to create a fancier version of the fish because it has no long legs or tails to use for knotwork.

Let's look at Celtic designs that can be added around the fish when developing them into fuller or more complex designs. In the example on the left, some Celtic spirals are added, as if the fish is leaping out of the waves.

Creating Celtic Animal Designs

✌ Creating Fish Designs

When combining multiple fish, try to do so in the most interesting way. The design on the right shows three fish swimming in a circle. By itself, it's quite simplistic. If the fish had some decorative scales and unique features, they could make an interesting border design.

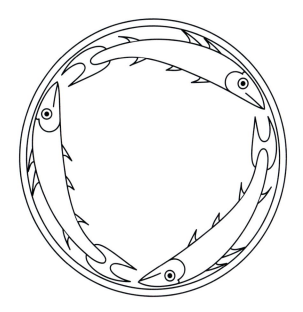

In this version, the fish overlap slightly to create some unique spaces that could be filled with more designs. This layout leads to a more interesting finished design.

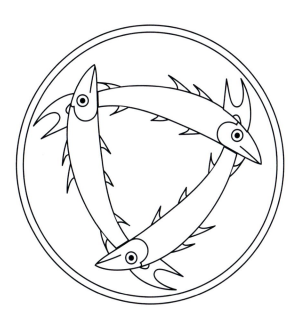

FISH

Creating Fish Designs...

In the center, draw a freehand trefoil or trinity knot, which is a knot that has three points, giving it the shape of a triangle. Twist out the ends of the knot into spiral swirls. Add the fish on top as if they're swimming in the spiral waves. Add some inner details to the fish, modeling them after the fish in *The Book of Kells*.

These fish are pretty skinny, so adding a double outline doesn't work for these examples. Instead add a double outline to the freehanded triangle knot in the center. With the remaining empty spaces filled, this completes the fish design.

Creating Celtic Animal Designs

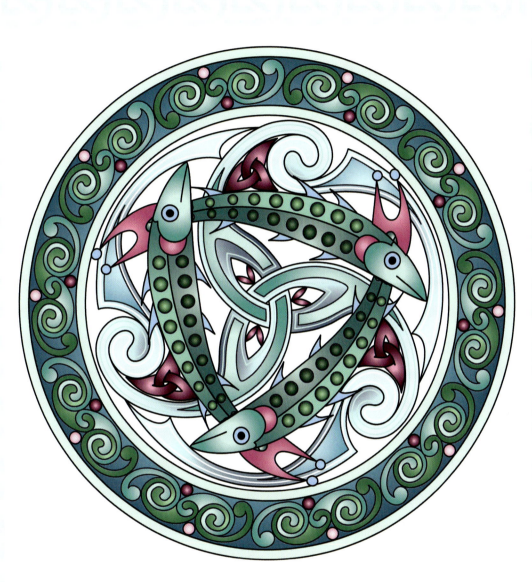

Salmon of Knowledge © 2019

FOXES

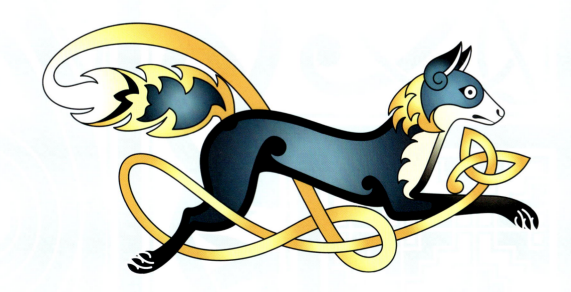

FOXES

The Basic Fox

There's no reason to limit Celtic animals to just the "traditional" ones seen in old manuscripts. Any animal can be drawn in a Celtic style. The approach is the same as for the other animals. Draw a rough shape using ideas covered in previous chapters, find some characteristics or elements that could be stylized in a Celtic way, and add additional knotwork or spiral embellishments.

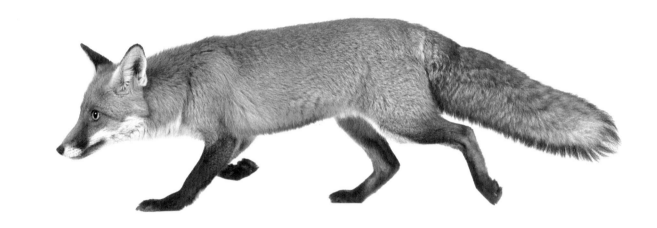

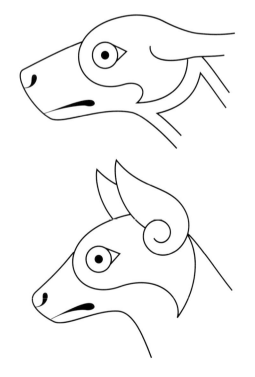

Consider the red fox. Use the hound as the basis for a fox. Then make some adjustments to make the fox look more "foxy."

In the photo above, the face is similar to a hound's, but it has a smaller, more tapered muzzle. Foxes have bushy fur around their cheeks, so make a slight adjustment to the speech bubble so that it has a big, wide sweep. That can imply fur later on.

Foxes have tall ears. Use the ears from the lion to give the fox larger, fancier ears than a hound's ears.

Creating Celtic Animal Designs

The Basic Fox...

Add some curls of fur to the cheek. These are similar to the curls for the lion's mane.

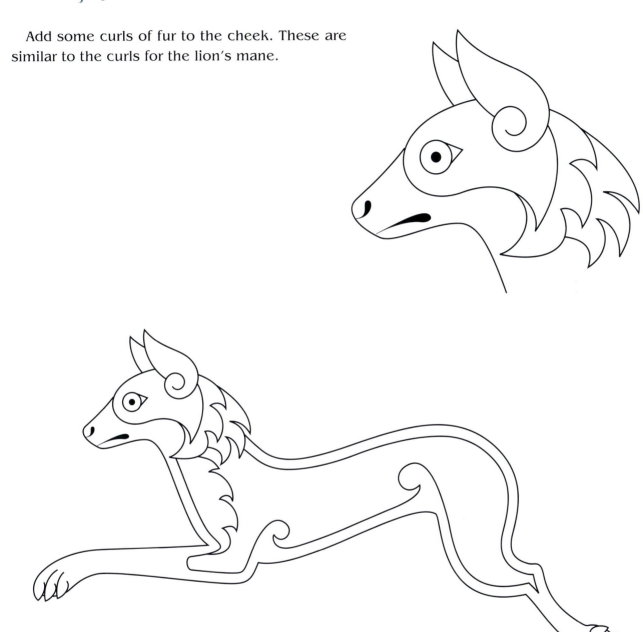

Use the dog or lion body as a model for the fox body. Draw two legs, stretched out as if the fox is leaping or running. Notice that a fox has daintier feet than a hound does, so draw the feet smaller than on the hound.

Add the inner outline and add some fur on the chest, as on the hare, so that he appears very fluffy like a real fox does.

FOXES

The Basic Fox...

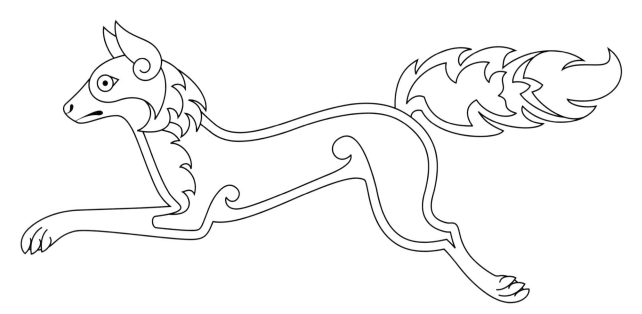

The tail is one of the most identifying features of a fox. Add a big, fluffy tail, with some inner details.

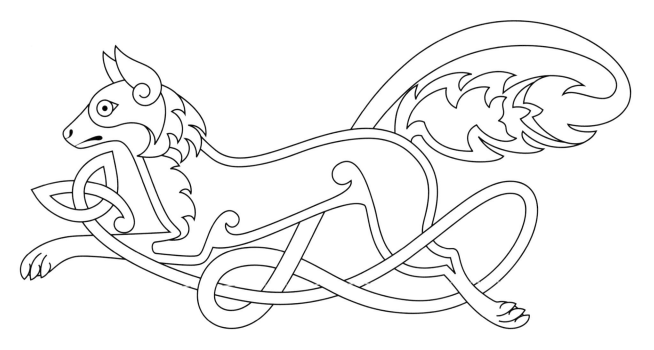

The fox's ears could be woven, as with the hound, but the tail is a better option. It's already long, so making it longer in order to attach to some knotwork matches the overall design. Extend the tip, and use that to create freehand knotwork around the design.

Creating Celtic Animal Designs

Creating Fox Designs

Draw three foxes running in a circle—the same format used for other animals. Then again, there's no reason why a design can't be in other shapes!

Drawing the foxes in a square offers a different design and allows a lot of room to weave their legs and show off their tails.

FOXES

Creating Fox Designs...

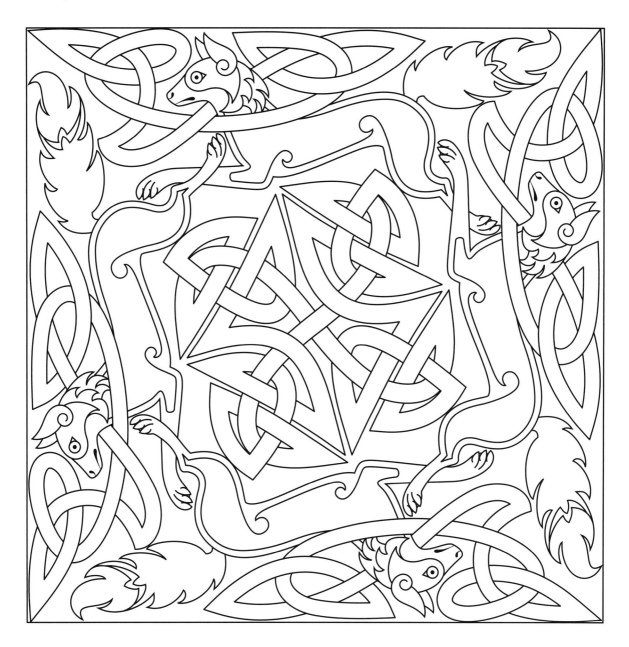

Use freehand knotting to create designs to fill the empty spaces. Begin to fill in some of the foxes' interior details. Consider how the animal would appear in nature. The finished design on the right includes leaves in the knotwork, which makes it look like the foxes are running through bushes or the forest. This provides additional things to color and extra details.

Creating Celtic Animal Designs

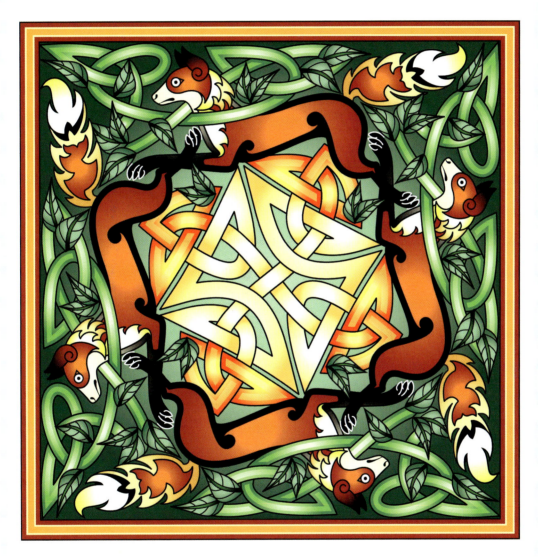

Autumn Foxes © 2019

BOARS

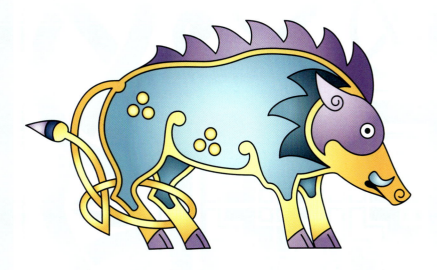

BOARS

The Basic Boar

The wild boar drawn here is based on the European wild hog. The boars are usually brown or blackish brown and have an upright mane running along their backs. Their tails also have a tuft of fur on the end. They aren't featured much in the old manuscripts, but they can be seen on carved stones, especially in Pictish works in Scotland.

The boar is featured in many of the old Celtic myths. It was a very significant animal in daily life, from hunting to eating. Manannan had magical pigs, who were reborn each day only to be feasted upon again. "The Tale of Mac Da Thó's Pig" is a fascinating Celtic myth.

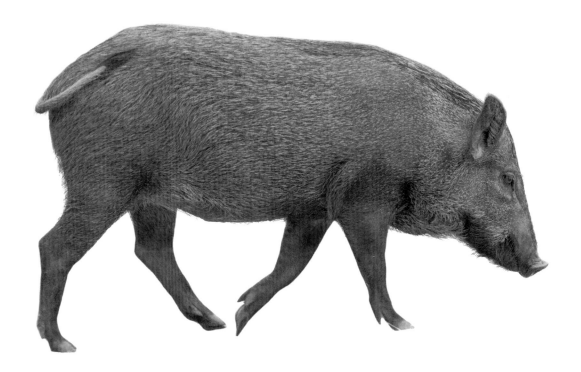

Some distinguishing features are the head and the neck, which are proportionately bigger and chunkier compared to the lion and dog heads. After the snout and the cheek, the neck starts out from the back of the head at about the same width as the body. The legs are very skinny in comparison but still follow the same general shape as legs in earlier chapters. These elements help make the Celtic boar look "correct."

Creating Celtic Animal Designs

The Basic Boar...

Begin with the face and the head, starting with the speech bubble. Notice the red speech bubble drawn on the photo to the right.

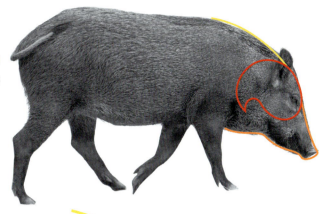

The snout is much longer and more tapered than the hound's or lion's muzzle, but it is essentially still a rectangular box coming out of the speech bubble. A short ear, like the lion's, matches well. The ears on a real boar are small compared to the rest of the head and body.

A little mouth suits the boar well. Add a curlicue around the nostril, as with the lion. For a tusk, draw a curved teardrop around where the mouth begins.

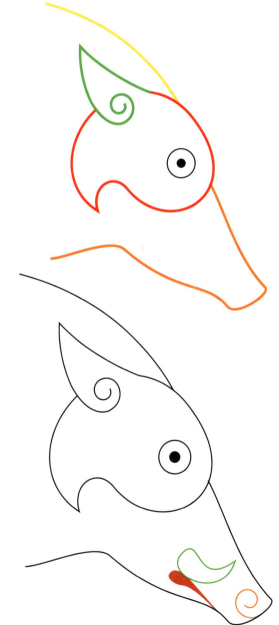

BOARS

The Basic Boar...

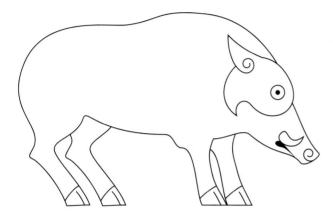

The boar has a very wide neck and a hump over the shoulders. The back leg is shaped similar to the hound's or lion's, but it's skinnier and shorter. The feet are simplified and squared off into little hooves.

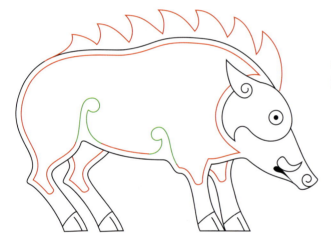

Add the double outline, some of the inner detailing, and the crest of fur along the boar's back.

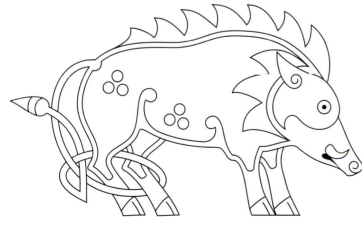

An extra ruff along the cheek gives the boar a shaggy look. The long, skinny tail can be freehanded into a knot that tangles around the design.

Creating Celtic Animal Designs

◊ Creating Boar Designs

Because the boar's legs are so short and he lacks long ears and a tongue, there aren't many body parts that can be woven except the tail.

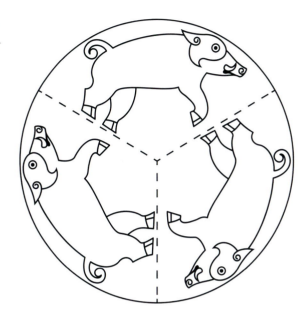

The fish presented a similar challenge, and other elements were included so that they could be woven around the animal. One option is adding another animal and weaving that animal's tail or legs.

A natural pairing for the boar is hounds. The design on the right shows some hounds hunting the boar and chasing him around the ring.

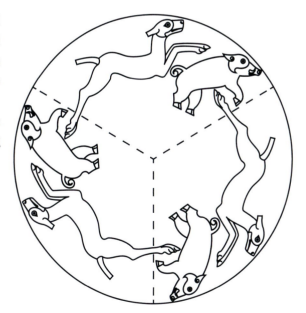

BOARS

Creating Boar Designs...

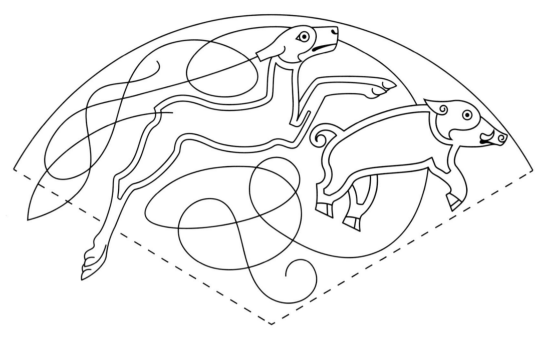

Fill the empty spaces with freehand knotwork. Add some inner details to the boar and the hound.

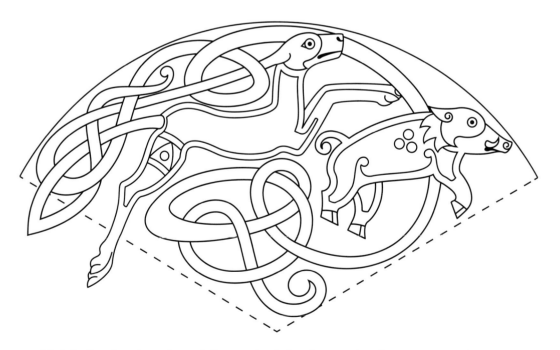

Finish the knotwork and the rest of the inner details on the animals.

Creating Celtic Animal Designs

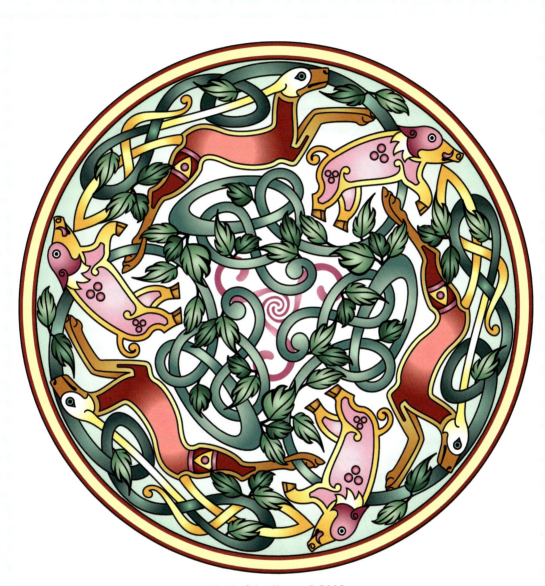

Hunt of the Fianna © 2019

TECHNIQUES & MATERIALS

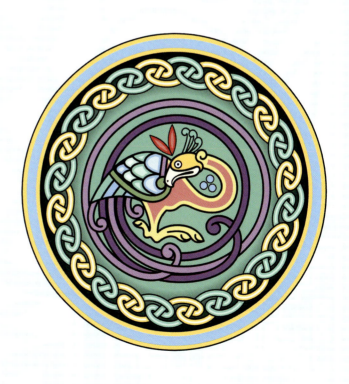

TECHNIQUES & MATERIALS

ꙮ Techniques

Transferring a Design

There are two tricks for transferring a finished design from scrap paper to good paper.

In the first method, flip the scrap paper so that the back side is facing up. Take an old-fashioned, hand-sharpened pencil; mechanical pencils don't work as well. Tilt the pencil on its side so that the exposed graphite lies on the paper. Then shade the back of the dot paper. Cover just the areas underneath the design. Hold the page up to a window. The light will show where there's missed shading. Once the back is covered, flip the sheet again and position it over the good paper. Use low tack masking tape or blue painter's tape to hold down the dot paper to the good paper so that it doesn't move.

Take a ballpoint pen and trace over the design. Press as lightly as possible to avoid embossing the outlines into the good paper below. The pressure from the pen transfers the graphite from the back of the scrap paper onto the surface of the good paper. When lifting the scrap paper away, the lines are redrawn on the good paper. The lines are ready for painting and are erasable, if necessary.

The second method is less messy. Buy a sheet of transfer paper that has the graphite already on it from an art store. Use this paper in between the scrap paper and the good paper, similar to a sheet of carbon paper. Reuse the sheet many times before getting a new one. The paper may be called transfer paper or graphite paper, and sometimes it comes in different colors! White transfer paper is very useful for transferring onto a darker good paper because it's more visible.

> ### ꙮ Tip ꙮ
>
> Before tracing the entire design, do a small section and then lift up a corner of the sheet. Be sure to press hard enough to transfer the design, but not so hard as to damage the paper, before continuing. It's better to have to redo a corner than the whole design!

Creating Celtic Animal Designs

❦ Materials

Pen and Ink

"Pen and ink" can mean a lot of different things and can use a lot of different materials. Let's focus on good works meant to be kept, framed, sold, or given away. You can draw Celtic designs with anything, but some materials are more archival than others, meaning that they last longer. The ink from some pens, such as ballpoints, fades or changes color over time, and some papers, such as newsprint, yellow and become brittle. This might not matter for sketching, but to make something that will look good ten years down the road, choose more archival materials. Most of these materials are available at art or craft stores.

Pens

Traditionally, a dip-style pen is used for pen and ink. As with old-fashioned calligraphy pens, purchase the nib for the pen and the body separately. The nibs come in a variety of sizes and should be chosen depending on the level of detail desired in the final piece. Some popular types are the Hawk and Crow quills. The constant dipping of the pen into ink can be messy and cumbersome, but these quills are excellent for making outlines in colors other than black. Choose any color!

Consider pigment-based pens that are like tiny felt pens but are of archival quality. These pens are also waterproof when dry. They won't fade, unlike a dye-based marker, and they come in several different tip sizes, which is helpful depending on the size of detail desired. I prefer these over pretty much anything and use different-sized tips for different parts of each painting, whether it's a tiny detail or a border outline.

Inks

Many colored inks are dye-based, so be careful when buying the ink. Check with sales staff or read the product information sheet to see if the ink is light fast. If it is not, the color will fade or change over time.

Another option is colored inks that are pigment-based, meaning that some colors are resistant to fading. Some colors still fade, but there might be a color option that works and does not fade. Look for a chart or product information sheet that describes which colors are light fast, moderately light fast, or not light fast at all.

A common version of pigment-based inks is liquid acrylics. They have the same properties as regular acrylic paints—there's a large range of colors and they're waterproof when dry—except that they're very thin and runny rather than pasty.

As far as a standard black ink goes, there are many versions to choose from. Usually these are labeled as calligraphy inks. When coloring the insides of knots, choose a waterproof ink to outline them so that the outside lines don't run.

TECHNIQUES & MATERIALS

Materials...

Paper

Papers chosen for pen and ink are usually smooth because of the detail involved. It's difficult to make a nice, straight line on very rough paper—it tends to wiggle around.

There are handmade papers with bits of leaves, petals, and bark in them that produce nice effects. Always test the ink on a scrap of paper to see how much it bleeds.

Watercolor paper is another option, especially if the plan is to stain the background or use watercolor paints on the paper after outlining. Watercolor paper is very heavy, and quality watercolor paper is archival. It comes in different levels of smoothness and thickness/weight, so choose the option that's the best fit.

Acrylics

Acrylic Paints

Acrylics can be used thick and straight from the tube or thinned with water or a thinning medium. All acrylics are waterproof once dry and can be cleaned up with regular soap and water. For thin and runny acrylics, look into a liquid acrylic to save time.

Artist quality is the best, but student-quality acrylic paints are more affordable. Both come in many bright colors.

Acrylic Paint Surfaces

Acrylics can be used on pretty much any surface, from wood to paper to leather. I've used acrylics to paint suede book covers and on wood, and I often use them on paper because they are so waterproof. It's best to use a very heavy paper with acrylics, or else thin the paint for use on lighter papers. When acrylic paint is used full-strength on a light paper, it makes the paper curl and pucker.

Canvas boards are available to paint on, but they usually have a weave texture to them, so they don't work as well for small, intricate images. These and stretched canvases—canvases stretched around wooden frames—are great for large works because the details are large enough not to be distorted by the canvas texture.

Acrylic paints work well on watercolor paper. Try to get a paper with a weight between 140 lb. and 300 lb. One option is watercolor paper mounted on stiff backing board—PK Board is an example—which is the best of both worlds: a watercolor surface with a stiff backing.

Materials...

Watercolors

Watercolor Paints

Watercolors come as a paste in a tiny tube or as a dried puck of paint. They are used diluted and are not waterproof. Upon making a mistake while painting in watercolor, wait for the spot to dry thoroughly. Then take a stiff, damp brush and scrub the spot out carefully, taking care not to damage the paper.

Watercolors can be cleaned up with regular soap and water. When working with watercolor on top of pen and ink, make sure that the ink used for outlining is waterproof. If the goal is to place layer upon layer of color without disturbing previous layers, look into a liquid acrylic instead. It provides similar results, but because it dries waterproof, it enables painting subsequent layers without redissolving the previous layers.

Watercolors, like acrylics, come in different qualities. Student quality is usually not as concentrated or as pure as artist quality. Good student-quality paint can be an economical way to purchase a variety of colors, which often come in sets. One advantage is being able to reuse a specific color from a palette after it's dried by rewetting it.

Paper

Watercolor paper is available in different formats. It can come in a pad, like a regular sketch pad; a block, where the sheets are glued all around the pad on the edges; or single full-sized sheets. If the plan is to soak the paper and work while it's very wet, use single sheets and stretch the paper before use so that it won't buckle. A nice alternative is the watercolor block. The blocks are glued around the edges, so paint straight onto the top sheet of the block. The glue holds the sheet flat, and any buckling usually straightens out once the sheet is drying while attached to the block. Remove the sheet from the block after the painting is finished and has completely dried.

Watercolor pads usually come in 140 lb. weight, although sometimes 90 lb. is available. Either is acceptable, but the 140 lb. is better when painting wet. It's preferable to have the paper be too heavy rather than too light, which risks wrinkling.

Single sheets come in a standard size of 22" x 30" and are available in standard weights of 90 lb., 140 lb., and 300 lb. If working very wet, consider the 300 lb. so that there's less worry about the paper buckling or having to stretch it.

Watercolor paper also comes in different textures: Hot-Pressed (smooth), Cold-Pressed (medium), and Rough. The most common texture is Cold-Pressed. Hot-Pressed is used for paintings with finer detail, and Rough is used to add some visible texture to a particular piece. Full-size sheets may be purchased and then cut down to the size needed. Choose what works best for individual projects.

Biography

Cari Buziak lives in Leduc, Alberta, with one cat, two dogs, and a couple of beehives. In a mix of old techniques (handmade gesso, egg tempera, and gold leaf) and new (several Mac computers), she recreates ancient manuscripts in painted and digital form for a wide variety of publishing, product merchandise, and fine art needs.

Idolized artists include Jon Muth, Charles Vess, Brian Froud, Maxfield Parrish, and Archibald Knox. Cari had the honor of being invited to Ireland for the summer of 2000 to work as the artist for an archaeological dig. The Ballykilcline Project, centered in Strokestown, County Roscommon, gave her the opportunity to reconstruct artifacts by sketching, create promotional paintings of the dig site, and further her own research into Celtic art and mythology.

Cari is one of the foremost artists of the Celtic art genre. She has published many books, and her work has been featured in design magazines. She has had gallery exhibitions in Calgary, Toronto, Florida, Indiana, Michigan, New York, Oregon, Wisconsin, Japan, and England. Cari has sold her art worldwide, and her artwork appears in private collections in Canada, the United States, Japan, and Europe.